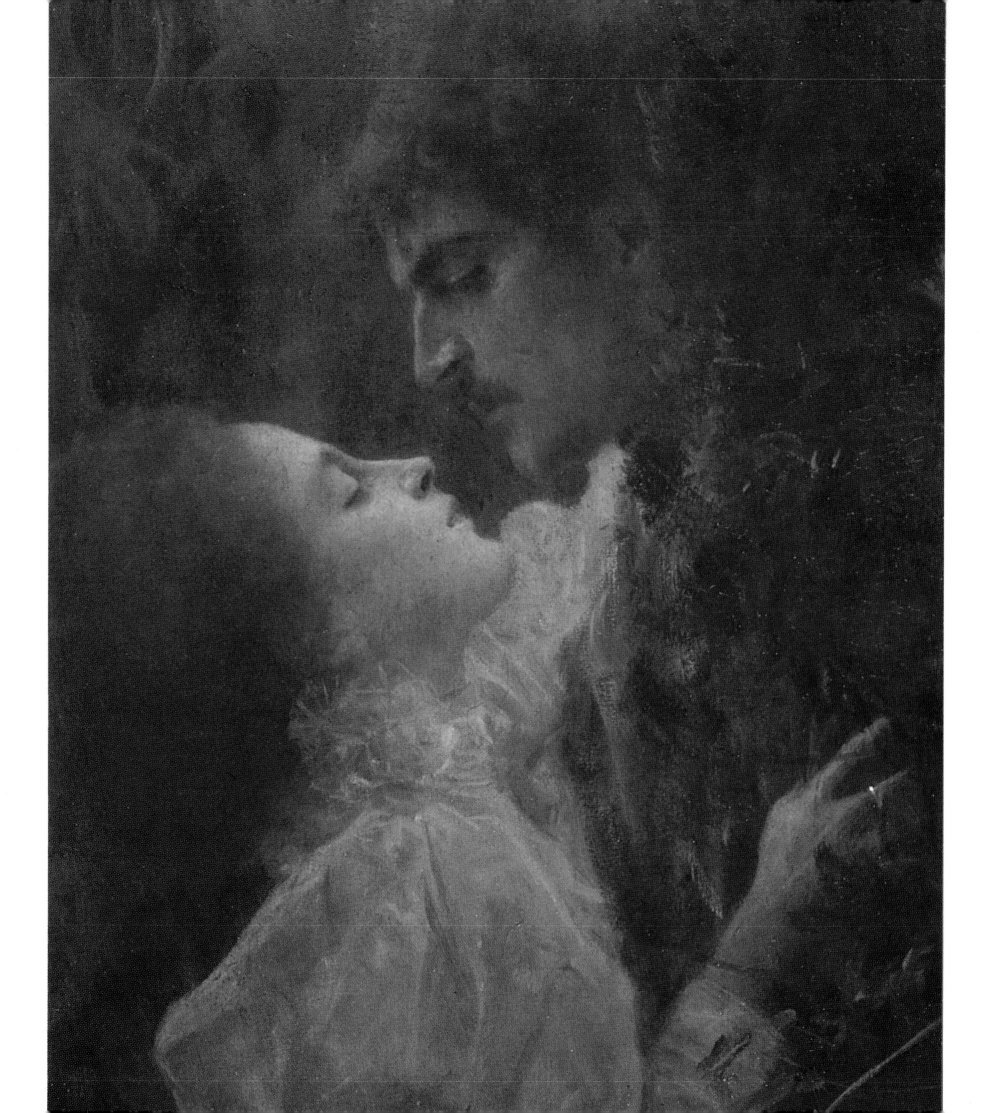

WOMEN

With an essay by Angelica Bäumer
and
a biography of
Gustav Klimt

Translated from the German by Ewald Osers

WEIDENFELD AND NICOLSON
LONDON

Frontispiece: Detail from *Love*, 1895 (Plate 1)

Galerie Welz wish to thank all those who helped in the publication
of this book and who made it possible to reproduce in colour
hitherto unknown works in private collections.

First published in Great Britain in 1986 by
George Weidenfeld & Nicolson Ltd,
91 Clapham High Street, London SW4 7TA

ISBN 0 297 79031 5

Typeset by Deltatype, Ellesmere Port
Printed in Italy

The first steps towards the Modern Movement were taken at the beginning of the nineteenth century, when Friedrich Overbeck and Franz Pforr, rebelling against the petrified academic style of Vienna, founded the *Lukasbund* (St Luke's League) in 1808, modelled on ancient religious associations. They moved to Rome with their companions in 1810 to lead strict monastic lives in the belief that only thus could they progress towards a new art. Known as the Nazarenes, they had outlived themselves by the middle of the century, trapped in the very eclecticism they had set out to fight. Any revolution was not brought about by them.

A more important move was that made by Theodore Rousseau, one of the principal figures of the Barbizon School, who, in search of light, along with his friends in 1848 exchanged the gloomy studios of Paris for the Forest of Fontainebleau to paint in the open air, exposed and surrendering to all nature's moods.

The next step was somewhat later, in 1874, when Cézanne, Monet and others exhibited in the studio of the photographer Nadar; the public, and more particularly the critic Leroy, sneered at 'impressionism'. It was also a time when evidence of other cultures was arriving from distant lands, from Japan, China, Oceania and Africa. Negro sculptures, the brushwork of Zen painting, Japanese woodcuts – all held the same fascination. Initially it was the traditional seafaring countries, those with great colonies, which first brought Oriental and African works of art to Europe; but the news of these discoveries spread rapidly and was received with interest and indeed enthusiasm, especially among artists in search of new directions. Eyes were opened, and new aesthetic and spiritual values were discovered which, at first in purely formal terms, penetrated the artistic awareness of Europe. Not until much later were their contents understood and their symbols gradually comprehended.

Austrian society and politics towards the end of the nineteenth century were characterized by a multiplicity of factors: the poverty of the exploited workers and their short expectation of life, resulting from appalling living conditions, poor hygiene and hunger – conditions which the young supporters of social democracy proposed to abolish; the prudishness of the Wilhelminian age, which was attempting to hide its hopelessness under a (by then threadbare) cloak of false and mendacious morality; a small aristocratic and political élite, which was perhaps beginning to become aware of the general malaise and the need for renewal but was incapable of action and so contributed decisively to the total collapse; and in between these a thrusting bourgeoisie, a middle class which – in Vienna – rallied around Karl Lueger who was seen as a guarantor of reconciliation of the worst antagonisms. That he was an avowed anti-Semite did not trouble anyone greatly: Vienna had a sorry tradition of anti-Semitism, which Theodor Herzl

confronted with his Zionist ideas of a 'Jewish State' as the only way of uniting the Jews, then just a people (defined by religious cohesion), into a nation (with its own government and its own country).

A similarly confused situation prevailed in art, where again there was a violent clash of opposites: a utilitarian, drawing-room style of painting, clinging to superficialities and long since devoid of any content; the vigorous style of the Munich school with its historical subjects and genre pictures; the beautiful products of English and Dutch *fin-de-siècle* painting, and in Norway, ahead of his time, Edvard Munch with *The Scream* of 1893, which went beyond naturalism and paved the way for expressionism.

And above it all there was Vienna, a city with an aura, with a culture that owed its variety to the stimuli of the Habsburg Empire's ethnically varied Crown lands, with a tradition in theatre, literature and music, but no less so in architecture, painting and sculpture – even though these representative arts had always been less important to the Austrian educated middle class than the performing arts. Even irritation at the underestimation of representative art in Austria had its own tradition. This emerges from all kinds of written records – some dating back to the turn of the century – when Ludwig Hevesi, Berta Zuckerkandl, Hermann Bahr and others tried time and again to gain for the representative arts the same kind of general artistic awarenes as was enjoyed by literature, music and the theatre.

We think of the turn of the century as the watershed between 'Old Art' and 'New Art', and speak of the 'end of a period' and of a 'new beginning'. But what was it that came to an end? Surely not art itself: art can never come to an end so long as man continues to exist, it may change, transform itself, postulate new content and forms of expression but it can never come to an 'end'.

Admittedly a social epoch was coming to an end, and with it certain artistic conventions. The decades from 1870 to 1920 were indeed a time of clashing contrasts, as the approaching industrial age vigorously claimed its due. Technology gained the upper hand. Suddenly there were motor cars instead of horses and carriages, industry was squeezing out artisans and craftsmen, mass-produced articles replaced individually crafted objects. In politics and society a self-assured bourgeoisie seized power from the aristocracy, while a Wilhelminian repressive mechanism was forced to watch the exposure of the soul by the psychoanalysis of Sigmund Freud. All these phenomena created tensions which found their reflection in the art of the turn of the century and which indicate clearly that

twentieth-century forms of expression have their roots in the middle of the nineteenth century. Arthur Schnitzler's *Flirtation*, first performed in 1895, and Sigmund Freud's *Interpretation of Dreams*, published in 1900, are just as much a reflection of an intellectual and social revolution as Theodor Herzl.

This changing scene was typical of Vienna, of the metropolis which drew its strength and its magic from the multi-layered nature of its population, which came from all corners of the Austro-Hungarian monarchy. But clearly old habits needed to be reviewed, and artists increasingly felt called upon to create something new, not only through their art in the quiet of their studios but also nationally, assuming responsibility for any political consequences.

This was the period into which Gustav Klimt was born. But he did not become a revolutionary. His art never belonged to any 'movement', even though it reflects the stimuli which, coming both from history and from contemporary society, from Europe and from Asia, were alive in the painter's consciousness.

Klimt came from a family of artisan-craftsmen. His father, Ernst Klimt, was a gold-engraver from a peasant family from Leitmeritz (now Litoměřice) in Bohemia, his mother was Viennese. The couple had seven children. Gustav was the second; his brother Ernst, two years his junior, as well as Georg, the third brother, also became artists – Ernst and Gustav were painters, Georg was a sculptor. Gustav executed numerous commissions in conjunction with Ernst, and Georg created many exceptionally beautiful frames for Gustav's paintings.

In 1876, aged 14, Gustav Klimt became a student at the Applied Art School at the Austrian Museum of Art and Industry (nowadays the College of Applied Art). In 1883 the Klimt brothers and the painter Franz Matsch moved into a joint studio because they were working together on nearly all their commissions. Important commissions for the studio included paintings for the Municipal Theatre in Karlsbad (now Karlovy Vary), for the Burgtheater in Vienna, and a number of ceiling paintings in the town houses of the aristocracy on the Ringstrasse, among which the 'faculty paintings' for the University have gained an unhappy fame.

Petty incomprehension, moralizing philistinism, blinkered professors and, last but not least, Karl Kraus's biting sarcasm gave rise, at the beginning of this century, to an art scandal of an intensity and passion that can scarcely be conceived today in an age of pluralism and total liberalism in the arts – a liberalism admittedly sometimes bordering on indifference. Then, however, opinions clashed hotly. What had happened? In 1894 the Ministry of Education commissioned Gustav Klimt and Franz Matsch to paint the ceiling of the Great Hall of the University, which had recently been built by Heinrich von Ferstel. The central panel, on the theme *The Triumph of Light over Darkness*, as well as one of the four side panels, *Theology*, were to be painted by Franz Matsch, while the remaining side panels, on the subjects of *Philosophy*, *Medicine* and *Jurisprudence*, were to be created by Gustav Klimt.

Klimt designed images of unprecedented force and originality of composition and thematic resolution. The professors, of course, had expected portraits of the great philosophers as a representation of philosophy, with perhaps a little something around them. Klimt, however, painted an allegory which, using pictorial means and an exceptional fantasy, caught on his canvas the great mystery of the universe, which, after all, it is philosophy's task to unravel. Klimt may not have been a speaker or a writer, but he was a man of all-round education. His acquaintance with literature and philosophy, and more especially with the history of art, are not only attested by his contemporaries but can be seen from his paintings. Klimt was familiar with the symbolic language of antiquity as well as with Nietzsche's writings, he was informed on contemporary art and interested in everything that was new: he eagerly absorbed influences and stimuli and incorporated them into his work.

The art critic Ludwig Hevesi, who was well acquainted with the picture of *Philosophy* (it was unfortunately destroyed by fire in 1945, together with other faculty paintings), had this to say:

'Klimt's *Philosophy* is a grandiose vision in which something like cosmic fantasy reigns. The whole scene still reveals the chaos from which it has struggled free, or rather from which it is continually struggling free, as a perpetually flowing life, ceaselessly coagulating into shapes and once more dissolving. We see a piece of the universe, full of mysterious ferment, of a motion whose rhythm can only be guessed at. The shapes, too, are veiled in a mystical vagueness which colourfully befogs the eye. The painter must treat that mystery, as far as possible, in purely pictorial terms. Moreover, it reveals itself to his imagination mainly as colour phenomena. In that universe the most diverse blues and violets, greens and greys are seething and intermingling, their ferment pervaded by flickering yellows, reaching a crescendo with real gold. One is reminded of cosmic dust and swirling atoms, of elemental forces constantly seeking objects upon which they may act. Swarms of light sparks are scattered about, each spark a star, a red, blue, green, orange or gold-flashing star. Yet this whole chaos is a symphony whose colours are blended

Philosophy, ceiling panel for the Great Hall of the University of Vienna, 1899–1907, destroyed by fire in 1945

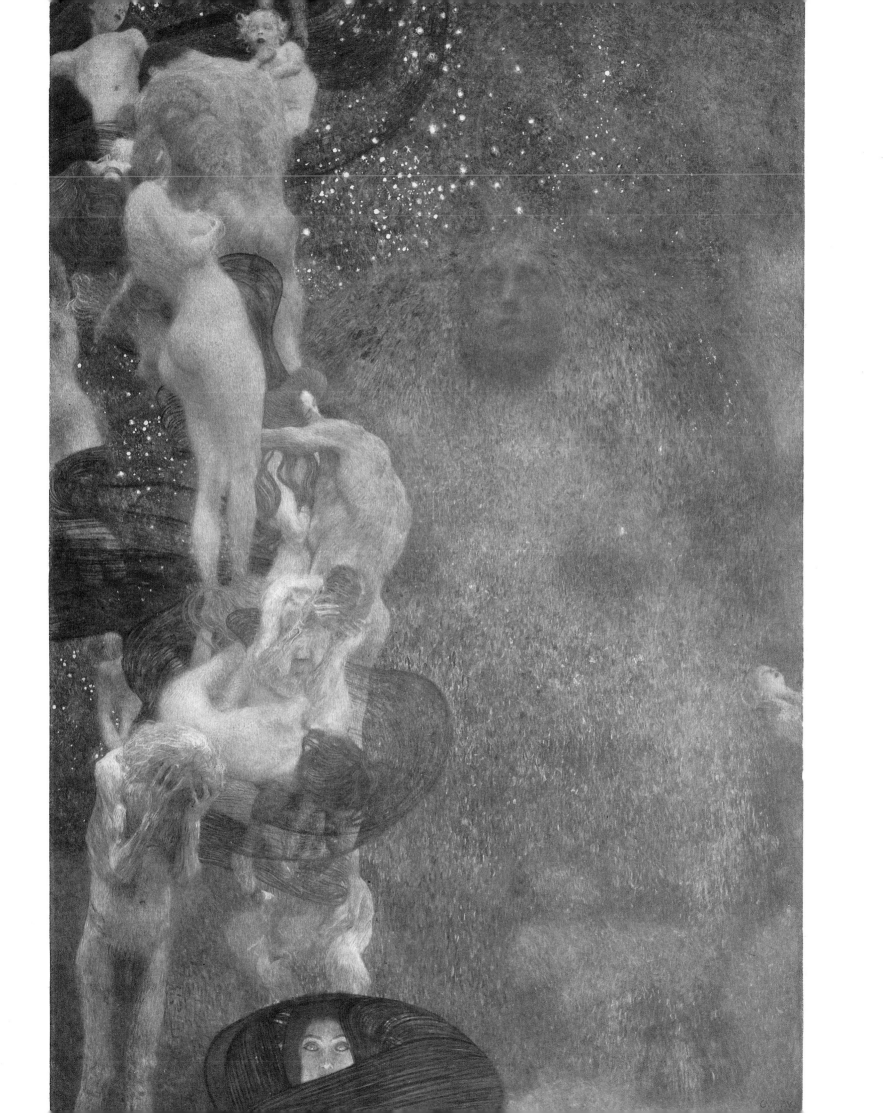

by the artist entirely out of his sensitive soul. As if in delirium he presents us with a harmony of colours in whose peculiar delicate details the eye turns to dreaming and loses itself. At one point in this swirl of colours a green mist gathers. Is it matter or green nothingness? Is it proto-matter or non-matter? The longer you look at it the more it becomes articulated. A stony motionless face emerges, dark as that of an Egyptian basalt sphinx. Other shapes join it, a woman's breasts, huge paws. It is a shape one can only guess at, made of matter one does not know. It is the riddle, the image of the cosmic riddle, an allusion to it. And across these silent veiled features, descending from above, there floats a bright stream of life. Of formed human life. Bright children, young bodies in flower, embracing each other, ecstasy and pain, labour, conflict, the struggle, the creation, the suffering of Being; finally that which perishes, the ice-grey old man who, hands pressed against his face, sinks downward towards the depths like an empty shell that has lost all strength. Yet down below a big living head appears, with wide-open seeing eyes and golden-red hair, with a laurel wreath of flowing veils. A finger against its mouth, it is silent, it gazes and reflects. It is illumined by fiery brightness, it glows and flourishes in the energy of its own light, it proclaims a creative force which is the equal of the chaos above. The figure which here surfaces into the formlessness of the transcendental is that of learning, or philosophy, or the discerning human spirit. The contrast between its light and the colourful misty shapes and flash-spattered darkness up above – that is Klimt's inspired pictorial idea. He had to paint an allegory of the most mysterious of sciences and he found a genuine pictorial solution to it. Naturally, it will not at first be properly understood, or rather perceived, but we have confidence in our public which, over the past three years, has so considerably widened its intuitive capacity. It will study this important work and will come to like it.'

Hevesi unfortunately was proved wrong. The artistic interests of the professors were not of a kind that would relate to what had been done here. They were reluctant to free themselves from the fog of the nineteenth century, and one of them actually admitted publicly that, though he did not know Klimt and had never seen the work, he was filled with a deep hatred of modern art because it was 'ugly'.

Such and similar devastating judgements, born of ignorance and indolence, were directed against a painter whose pictures are today counted among the most beautiful, the most tender, the aesthetically most pleasing works of art in history. Not only did the academics not trouble to conceal their absence of artistic response, but they were even proud of their stand since they still felt a commitment to the 'classical' ideal of beauty, and as cultured men they assumed they were right since at that time, as is still the case, anyone with two eyes in their head felt he knew what art was. Any of them would have vigorously objected to an outsider's intrusion into the realms of science or to similar references to 'ugly' medicine or 'wrong' mathematics. Karl Kraus, too, disliked Klimt's manner of portrayal and, with his notoriously acid and simultaneously malevolent and cynical pen attacked not only the faculty paintings but at the same time Klimt in general. He, too, ultimately revealed that he was concerned more with polemic than with artistic perception. This is what he wrote about *Medicine*:

'The *Medicine* row is assuming even more disagreeable forms than the *Philosophy* hullaballoo. The eighty-seven university professors lodged a complaint against the threatening disfigurement of their building . . . The argument is no longer about whether or not a bad picture by Herr Klimt is to be affixed to the ceiling of the University's Great Hall. The argument is about other primal problems of mankind, and unfortunately also about some which we had thought had long been resolved. The fact is that fifteen Members of Parliament – most of them party leaders – have taken the liberty of tabling a question to the Minister of Education on the commissioning of *Medicine* at public expense. Even someone who might dispute the right of university professors to reject something that disfigures the University could surely not wish for a more competent forum than Parliament for rejecting something that costs the tax-payer money. Far from it. The same diehard liberalism . . . raises a hue and cry when Members of Parliament venture to check the nonsensical spending of money by a ministry confused by incompetent advisers. The kind of absolutism under which the stock exchange does well for itself suits our liberal press, and the kind of absolutism under which the Secession is doing well for itself gives pleasure to our modern art journalists . . . But woe betide any Members of Parliament if they try to hold the Minister of Education responsible for tax-payers' money being squandered on some miserable botch exhibited at the Olbrich shrine! Thus cries the Secession when it is worried about the freedom of art. But on the other hand these gentlemen are ready enough to allow an appeal to a forum of "laymen", even if these are industrialists, peasants, grocers, or actually professors.'

It was a big scandal at the time. Hermann Bahr made a speech and others likewise came out passionately for or against Klimt's paintings. But this is not the place to go into the affair in detail. Klimt's faculty portrayals are important to this discussion solely because they are dominated by woman, by the female body: by Hygieia and the nude young woman filling the left-hand section of

Medicine, ceiling panel for the Great Hall of the University of Vienna, 1900–7, destroyed by fire in 1945

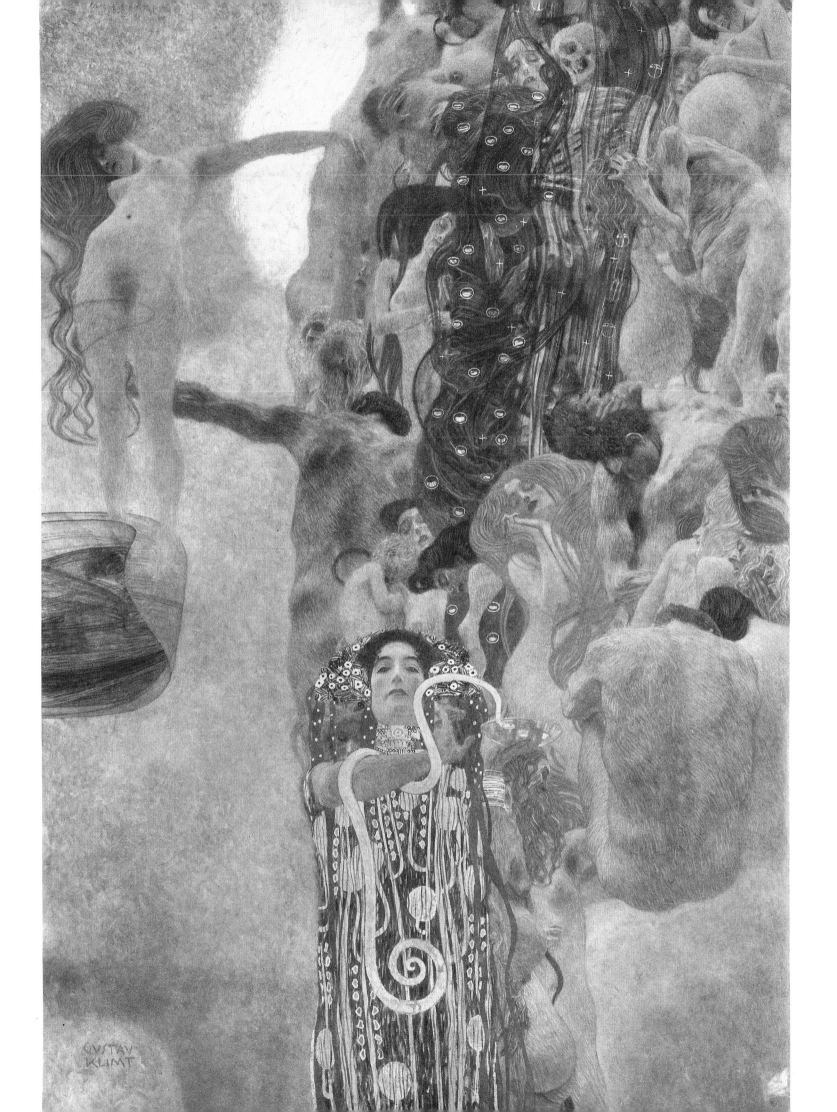

Medicine; by the mysterious illuminated head of knowledge, that sphinx-like figure almost hidden in the shadows in the painting of *Philosophy*; and by the female figures who predominate in the composition of *Jurisprudence*. How is this to be understood? Surely these three sciences had always been practised by men? It was men who pursued philosophy, practised medicine, made laws and administered justice. But is it an accident that these sciences in German are of feminine gender: *'die' Philosophie, 'die' Medizin, 'die' Jurisprudenz*? It is possible that Klimt intended his treatment to be understood in this way, but it is also possible that to Klimt woman is the focus of all things, that, through her earthy, elemental essence, she is life itself, the all-determining and all-embracing being. If one takes an overall look at Klimt's oeuvre one is bound to take this idea seriously and to make it the basis for studying and judging his work, and for trying to understand his statement as a painter, his artistic message, from the way he has given shape to woman in his art and from the amount of space he has given to woman.

The very first pictures of the young painter were concerned with women, both those of his family and, more especially, allegorical subjects. The comissioned theatre decorations in Karlsbad (Karlovy Vary) and later in the Vienna Burgtheater already reveal his joy in painting delicate girlish bodies and female figures, with softly flowing garments and dreamy eyes. Admittedly, these are still pure decorative art, painting executed to order, but even these early works, created jointly with his brother Ernst and his friend Franz Matsch, reveal a good deal of his subsequent handwriting. The first time this emerges fully was probably in the painting *Love*, done in 1895, when he was twenty-three. Undoubtedly Klimt is here still influenced by the *Jugendstil* and the Munich artists; traces of the Nazarenes and the Romantics can even be discerned. Yet for the first time Klimt places lurking figures in the background, figures of which only the heads are visible, thus making them even more sinister, as a reminder that this tender and sincere love will be exposed to threats: jealousy, envy and eventually death. This 1895 picture of *Love* and the unfinished *The Bride* of 1918 differ from each other in perfection and mastery, in maturity of expression, in vigour of composition – but not in spirit. Both embody the mystery of unity and separation, reminding us that even at the peak of happiness unhappiness is already lurking, that at life's zenith death is already extending its skeletal hand, and that the powers of darkness are ever-present and menacing. In many portraits of Viennese society women Klimt has dispensed with symbolic embroidery, but wherever he considered it possible and necessary he has added his symbols – as a seer perhaps, as a warning voice, but certainly as a painter concerned with a composition which was to contain, at one and the same time, the obvious and the mysterious. Thus not one of his great paintings is free of that ambiguity of symbols which lend their contents a shape and weight beyond the purely decorative; more than his portrayed women – Zuckerkandl, Bloch-Bauer, Knips, Beer or Primavesi – these backgrounds provide the key to an understanding of his painting and of his relationship to women.

Gustav Klimt was a welcome guest in the houses of elegant Viennese society, where mothers and daughters would sit for him and where husbands would gauge their own importance by the portraits Klimt painted of their wives. But Klimt was not just a painter. He was one of the founders of the Vienna Secession and he was extensively involved in the foundation of the Wiener Werkstätte, the Vienna Workshop. Berta Zuckerkandl, the art journalist and a student and admirer of Klimt's painting, writes: 'The spark for the foundation came from Klimt, the leader, the guide, the universally acknowledged genius. The man who had no precursor and who will have no follower. A unique solitary figure, risen up from the deepest depths of a tribe, of a nation. Naive and sophisticated, simple and complex, but always inspired. Thus the young painter Gustav Klimt became the figurehead of the revolutionary movement in art which, beyond the frontiers of Austria, succeeded in carrying its banner throughout Europe.'

Klimt was thirty-five when the Secession was founded and forty-one at the foundation of the Wiener Werkstätte. He was not only a founder member but remained closely linked to it all his life. Countless textile patterns, dress designs and pieces of jewellery were the products of his fantasy. Klimt was associated with Emilie Flöge who, together with her sisters, ran one of the most elegant fashion houses. Klimt repeatedly created designs for her which expressed his love of decorative elements and which testified to the belief that nothing should be too mean to the artist, that applied art, too, is art, that a dress, a curtain, a table, chair or carpet, a dinner service and cutlery all form part of one great whole that is the culture of life and ultimately is an art form in its own right.

Jurisprudence, ceiling panel for the Great Hall of the University of Vienna, 1903–7, destroyed by fire in 1945

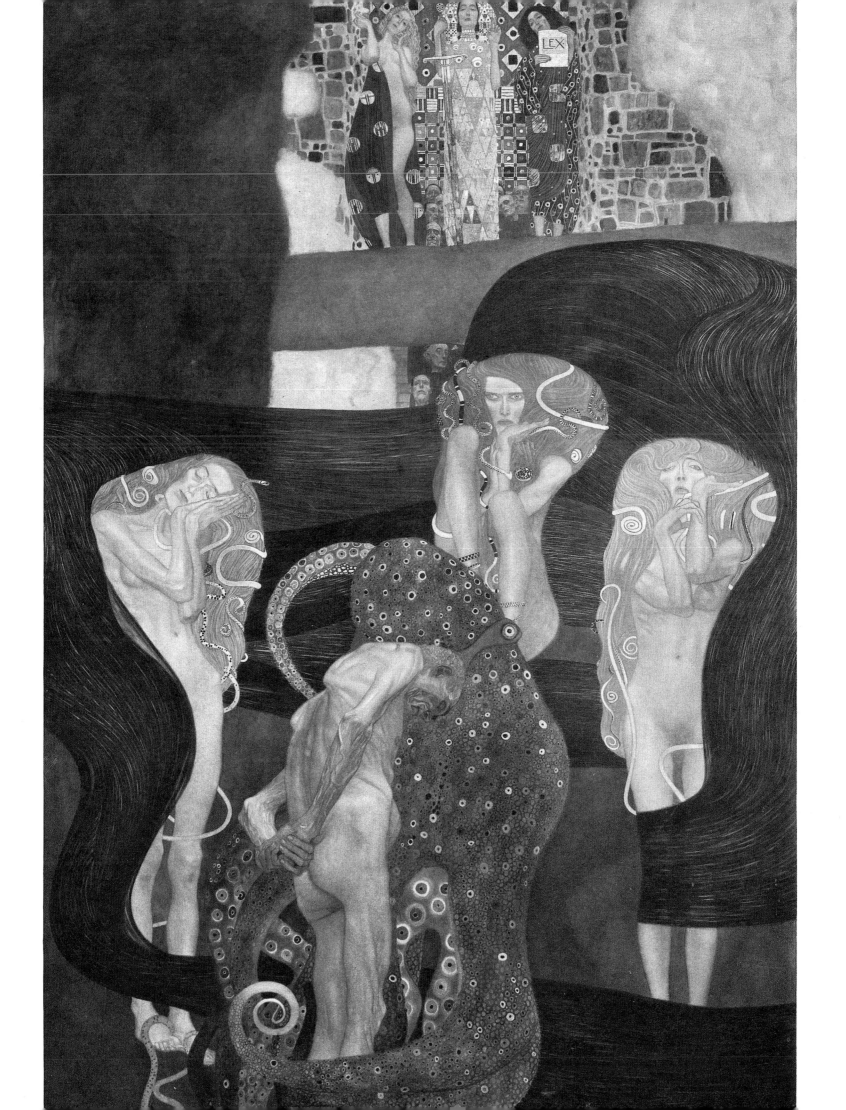

Gustav Klimt collected Oriental, mainly Chinese and Japanese, *objets d'art*. In his possession were paintings, vases, small sculptures and also fabrics, and there can be no doubt that they both provided him with ideas and complemented his own thoughts and ideas on painting.

It was, above all, in the portraits of Viennese society women that Klimt enriched the backgrounds with Oriental motifs. These include such famous paintings as his portrait of Friederike Maria Beer, behind whom a battle rages taken from the design on a Korean vase, or the portrait of Adele Bloch-Bauer at whose shoulders can be seen horsemen and Buddhist figures, or even that of Elisabeth Bachofen-Echt who stands against a dramatic background which gives the painting a most unusual tent-like composition. But also in portraits of women unknown to us we often find a variety of Oriental themes which Klimt seized upon in order to give his picture additional depth and significance. Thus we see flying behind the *Lady with Fan* various exotic birds very much in the Japanese style of painting. Altogether Klimt's encounter with Oriental art fundamentally influenced his ornamentation and his very idiosyncratic manner of decorative composition.

The slogan was *L'art pour l'art*: art was allowed to be its own *raison d'être*, there was a new freedom from all constraint, women's corsets fell victim to a newly awakening physical awareness, to an intellectual as well as a physical reform movement, women were for the first time studying medicine and science, they openly avowed love, and their courage in shaping their own lives clashed with old conventions and an anxious clinging to tradition and stability. The Imperial House and revolution for a short while co-existed side by side, in a state of supreme tension and alertness, ever ready to engage in battle.

Thus, long before the First World War destroyed the social hierarchy and before political change upset our picture of the world, a re-orientation had been set in motion. War was merely the final and horrible consequence of the transformations which had preceded it. The puritanism of the nineteenth century, the false sham morality of a society at odds with itself and the abrupt emergence of new potentials of life also brought new freedoms to the artist. Gustav Klimt was clearly aware of these freedoms and made full use of them in his painting and also in his private life. Both in a veiled and in an open manner Klimt in countless drawings and paintings professed his belief in sensuality, in sexuality as the mainspring of human existence and the pursuit of happiness. His own readiness for love, his sexual vitality, his numerous love affairs

of which only two lasted for any length of time – all these are well known. Scarcely anyone who has written about Klimt has avoided the temptation of, overtly or covertly, presenting the painter's sensuality or of discovering phallic symbols in as many of his pictures as possible. Sexuality is in fact an infinitely varied theme in Klimt. The naked woman, surrendering herself, falling asleep after love-making, satisfying herself, alluring, waiting for her man with legs apart and lips half open, writhing in all directions, ever ready for love-making – all these Klimt has depicted countless times. In so doing he adopts the role of the dominating male, regarding the female with a great deal of love and a great deal of knowledge.

Danae is erotic even in her sleep, the golden seminal stream flowing into her womb while she, with unconscious lasciviousness, still slumbering, receives and accepts it. Klimt's ecstasy is that of a childlike, naive and yet knowing and depraved woman with a fair skin and rosy breasts, with red hair and half-parted lips, her closed eyes ready to immerse themselves instantly into the man's gaze if he should turn to her with tenderness.

Were all women – are all women – entirely in agreement with this role of a seductive, available Eve? Was there no revolt against man's dominance, against his possessive claim? Or were women in 1900 actually grateful for a deliverance which at last permitted them to admit to themselves their own sexuality, to experience their bodies and their nakedness as a source of happiness? Society's bourgeois morality had come up against opposition: the desire for freedom, for an end to all constraints, was stronger than an outdated morality.

Much had been unleashed at the turn of the century, much had begun to slide like an irresistible avalanche. The most disastrous consequence probably was fear. Fear as an indefinable force, as a threat to our strength, as a brake on our high-flying hopes and plans. This fear, articulated in Freud's psychoanalysis, has largely brought about the changes which confront us today. The definable, real, fear which man knew in the past has become an irrational fear, Freud's *angst*. Although we still fear specific dangers, nuclear bombs, the destruction of the environment, or disease, there is a new unease now, the fear which exists between man and woman – a realization that togetherness is impossible and total loneliness the inevitable result. While woman has liberated herself from the contraints of society, no longer being man's appendage, she has instilled fear in man. She no longer is his creature, she has become her own creature, one which copes astonishingly well on her own. Men found themselves utterly

perplexed, and to this day have not grasped what has actually happened. Gustav Klimt has given pictorial shape to this *angst* in his allegorical paintings. While expressing his admiration for woman's beauty he also articulated her remoteness, the unbridgeable distance between man and woman. Thus he painted woman as a sphinx, that eternally mysterious creature unapproachable by man because it would crush him with its strength; as Judith, the woman who conquers man not with his own weapons but with her peculiar power and logic; as Salome, who in the insatiable intoxication of her sensuality demands the head of her beloved because he is not prepared to surrender to her; and also as the serpent, seduction, to which man meekly surrenders, against his better judgement, because loneliness seems to him even more terrible than expulsion from paradise – he is lost one way or another. He painted woman as a witch, as a sorceress, with the knowledge not only for mixing the love potion but also for destroying man; as the vamp of the *fin-de-siècle*, the seductress, the *femme fatale*, without salvation for the man thirsting for love; and finally as *Nuda Veritas* the 'Naked Truth'.

What else are all these symbols of art other than man's insuperable fear of woman? Women in Klimt's work are stylized into figures of fantasy divorced from harsh reality, the fear of which chokes our capacity for understanding, leaving only dull instinct. The demands of nature time and again drive man into woman's arms, but he no longer finds a haven there, no peace or safety, only coldness, distance and insoluble incomprehension. The young man of the nineteenth century has lost out. He has become a sufferer through his longing for woman, he has become a loser in his desire to possess her, he is a failure in his hope to understand her. What is left is only brutality in the struggle for dominance in relations between the sexes. Freud spoke of a death wish in love. But surely only because the most human of all needs, the need to be allowed to love and to be understood, is so infinitely difficult to satisfy, or perhaps, with the exception of brief moments, impossible to satisfy, and because man has suddenly realized this. It is a realization which we find hard to bear.

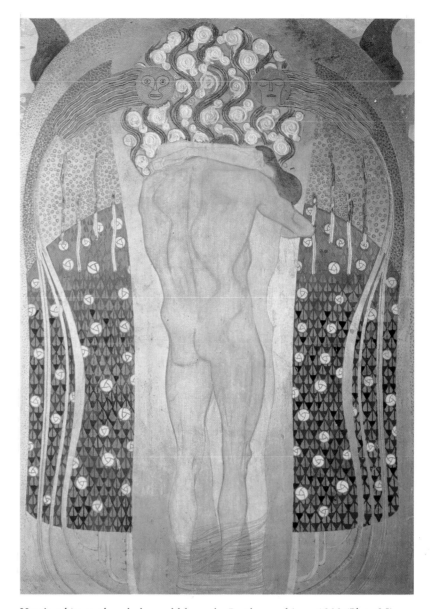

Here's a kiss to the whole world from the Beethoven frieze, 1902 (Plate 25)

The Kiss, probably one of Klimt's best-known paintings, is regarded as the symbol of union between man and woman, as the fusion of two bodies into one – but is it really that? Klimt has enveloped this fulfilment of amorous longing in gold, in sensually lively colours and patterns. Yet the woman's hand round the man's neck is not lying relaxed on his skin but is cramped, the fingers hidden, almost making a clenched fist. His hands around her are open, holding and supporting her. He bends down to her lovingly, but she has turned her head sideways, offering him only her cheek and not her lips. And those dreamily closed eyes – could they signal resistance rather than surrender? Is this painting perhaps not a testimony of total fusion but actually one of total alienation between man and woman? It may be that this development had not been triggered off by woman, or at least not consciously; yet woman made use of it for her own self-assurance and for her freedom. It may not have brought her happiness. Release from constraints invariably produces new ones. And the experience of *angst* was

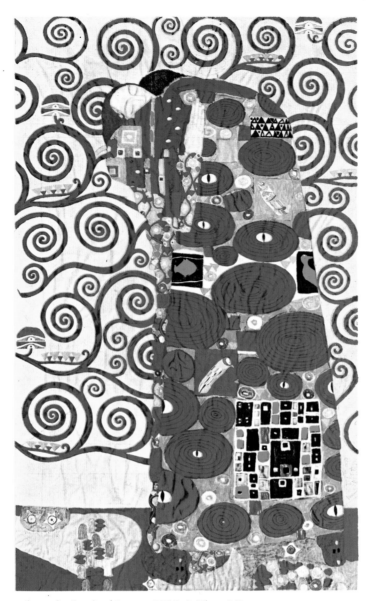

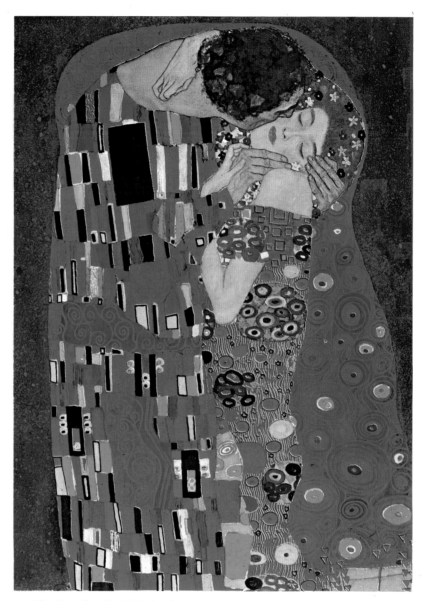

Fulfilment from the Stoclet frieze, *c.* 1905–9 (Plate 36)

The Kiss (detail), 1907–8 (Plate 37)

not confined to man.

In the most tender of all his love paintings, *Love*, dating from 1895, just as in the faculty picture of *Philosophy*, Klimt also gave expression to that *angst*. Behind the pair of lovers, engrossed in mutual contemplation, lurk the lemurs, faces of death and masks of jealousy. The background presages evil, not good – *angst*, therefore, even in greatest happiness. *Philosophy* is actually stifled by *angst* and darkness. The light of truth is shrouded and hidden behind veils, men cover their faces with their hands, the woman in the dark cloth has a fixed stare; in the posture of the figures, in the eyes of the woman there is fear and horror, not the blissful knowledge of philosophical certainty and clarity.

On one occasion Klimt withdrew a picture from an exhibition at the Secession Gallery because it was causing 'fear'. Unfortunately it is not recorded which picture it was. Klimt therefore knew about fear. He was a highly conscious artist who perceived the troubles of his age and who constructed his compositions very deliberately, with a sure instinct but also with clear calculation. And when in *Hope* he has painted death's heads in the background and given her an extremely critical gaze, when he has laid her hands on her body in

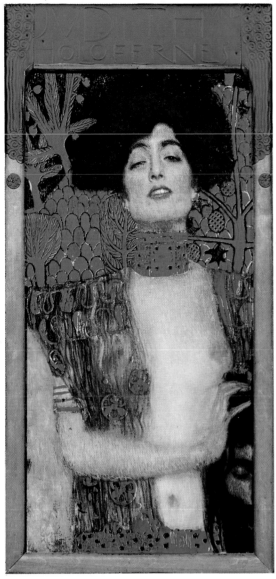

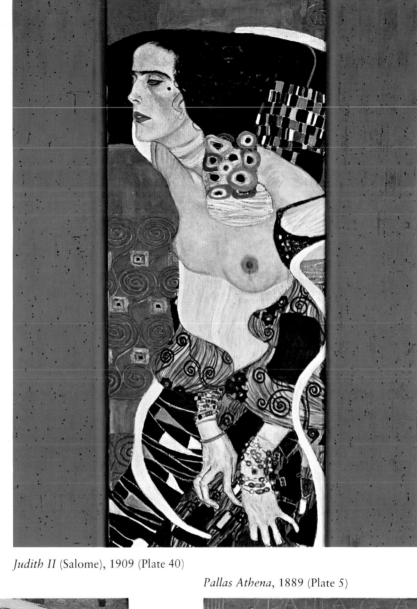

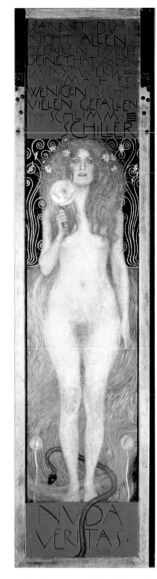

Judith I, 1901 (Plate 15)

Judith II (Salome), 1909 (Plate 40)

Nuda Veritas, 1899 (Plate 12)

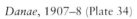
Danae, 1907–8 (Plate 34)

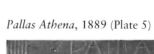
Pallas Athena, 1889 (Plate 5)

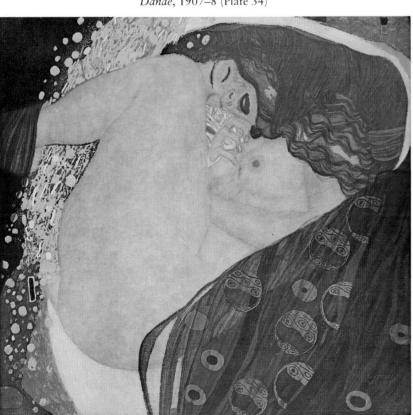

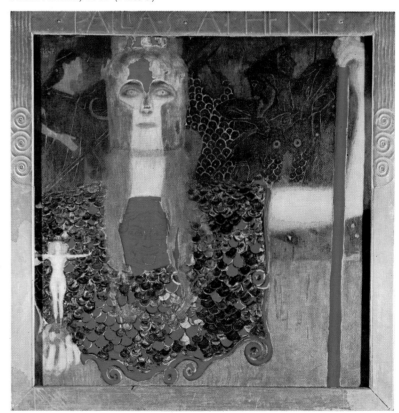

a manner that seems to protect not her unborn child but herself – is this not also an expression of vague but menacing fears?

If one engrosses oneself in the representation of women in Klimt's work one discovers a few fundamental facts. The first of these is the beauty with which Klimt invests all his portraits. Even the old woman in *The Three Ages of Woman* still has grace – in the way her wavy hair falls and in the way her hand, marked by work and the years, rests gracefully on her thigh, vigorous in spite of all weariness. Naturally, beauty is found mainly in the representation of young women and girls. Note the delicacy, the elegance, the seductive magic practised by Klimt, bending a head, bowing a slim body backwards, allowing another to stretch in lustful surrender. The pregnant woman is full of erotic charm, and her delicate face, with the wonderful hair that flows around it like a halo, looks openly and proudly, defiantly and nobly into the eyes of the beholder. Sonja Knips, sitting in her garden chair surrounded by bright and fragrant flowers, is herself like a flower, and yet has wary eyes and a certain tautness, as though she had just been told some news. (The book in her hand is one of Klimt's lost sketchbooks which he had got her to hold for effect.) The proud unapproachable Judith is full of strength and confident of victory. And finally Emilie Flöge, the woman in his life, the only one he called for when he collapsed from a stroke, is painted with such tenderness in an early pastel that one believes one can actually feel the relationship between the two. Fritza Riedler, Margaret Stonborough-Wittgenstein, Adele Bloch-Bauer, Amalie Zuckerkandl – they are noble images painted by Klimt. Certainly these women were beautiful, striking, exquisite and elegant, certainly they posed for Klimt in the most effective way, put on their most expensive dresses and made themselves up before entering his studio. And Klimt, of course, saw all that – he derived pleasure even from superficial adornment. But to this outward beauty he has added an inner one, through his genius he has revealed the essential. Thus decoration became art, superficiality became depth, fashion became beauty. He never denied decoration, nor his liking for fashion. Gustav Klimt, as did so many of his best contemporaries and especially his Secession friends, realized the importance of the total work of art. It was art that would bring everything together in an ecstasy of *joie de vivre* and in the service of beauty.

Klimt used gold in many of his paintings both as a tribute to the past and as a means of attaching great value to the present. For the town house of the Stoclet family he designed a mural décor which, for elegance and precious materials, may claim to rank equal with the most remarkable works surviving from Roman country residences. For the Beethoven frieze he depicted *The Sufferings of Feeble Mankind*, *The Hostile Powers* and *Corroding Grief* with, undeniably, far greater pictorial vigour than *The Longing for*

Happiness Finds Solace in Poetry, which, even though he immersed it in gold, he does not really seem to have believed in. If one looks at the back of the man engaged in the *Kiss to the Whole World*, one will find that it is not released or relaxed but taut, as though in fear. This is one more example of Klimt's profound awareness of the deep-rooted problems of his time and of his hymnic vision of *The Well-armed Strong One*.

Was there not by then a foreboding of the darkness which was shortly to descend in a murderous war that would extinguish everything in which mankind had believed and hoped? The fall of an empire also entailed the fall of an ideology – and of that very specific Viennese magic which nobody has expressed with greater genius than Gustav Klimt. The lemurs and the hideous masks of death, the skeletons and the lurking figures in the backgrounds of Klimt's pictures now became a sad reality, emerging from the gloom and populating the foregrounds.

But Klimt experienced this only briefly. He was able to stay with his beauty and with his dark forebodings. Even in the midst of horror the flowers still bloomed for him, women still smelled sweetly and temptingly in an intoxicating mix of emotion and colour.

Initially, therefore, it was female beauty that fascinated and attracted Klimt, and to which his own longing for beauty responded. But there was something more that interested him in woman, something that he expressed in his pictures time and again – woman's freedom. This genuine and inalienable freedom lies in woman's nature, in her essence as a creature, and could not be destroyed by social oppression. From this, however, arose a third element which attracted Klimt – woman's loneliness. These two conditions, freedom and loneliness, are inextricably linked. Klimt may have understood them unconsciously, perhaps instinctively. The eyes of many of his female portraits certainly hold a knowledge of that mystery, and it is largely this that accounts for the emanation, the eroticism, the meaning and the magic of his paintings.

Klimt represented Athena three times. He first painted her in the spandrel of a pillar in the Kunsthistorisches Museum: there she stands, proud, erect, a Nike in her right hand, a spear in her left, stoically regarding the visitor – theatrical decoration with an intellectual background.

The second Athena is more stylized, strongly abstracted, and appeared on the poster for the first exhibition of the Secession; by this new form of poster art Klimt intended to convey that the young

Portrait of a Lady, 1907–8, privately owned
The Sisters (Friends III), 1907–8, privately owned

16

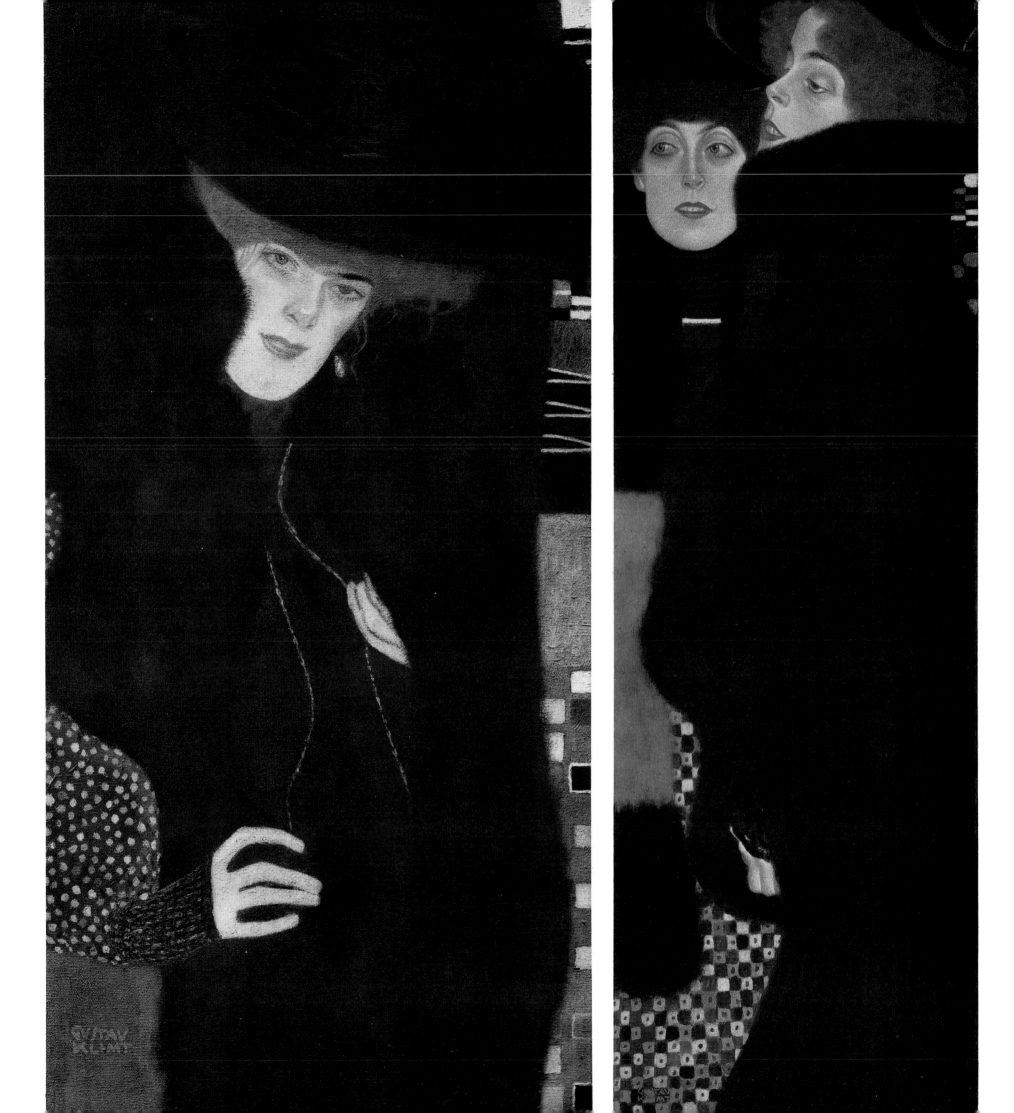

had set out on their march against the diehard geriatric artistic Establishment of the Künstlerhaus. New, too, was the idea expressed over the doorway of the Secession Gallery, which suggests a temple rather than a neo-classical museum: 'To the age its art, to art its freedom' – words which have lost nothing of their topicality to this day. The Secessionists called their periodical *Ver Sacrum*, and a sacred springtime was intended also for art. Hence Athena on that poster is decidedly militant. She is going into battle for that springtime of the artists.

Gustav Klimt painted a third Athena in 1898, in a square format, gleaming with gold, with a visored helmet which reveals only a resolute, sphinx-like smiling mouth and a pair of piercing cold eyes. Around these three pictures of Athena Klimt grouped his symbols. Whereas in the Kunsthistorisches Museum the goddess has only her customary attributes, Nike and spear, and whereas the folds of her garment still seem to be more important than any symbolic idea, the emphasis in the poster is on the oversized gorgon breastplate, the spear held high, and on the composition – the way Athena does not look at the spectator but watches the fight between Theseus and the Minotaur, which is represented as if on a stage. The son killing his father is symbolic of the Secessionists' exodus from the Künstlerhaus. The third Pallas Athena finally is the heroine – neither decoration nor utilitarian graphic art but victory personified. In the background the fighters have not yet separated but they are now only shadows. A priestess raises an imperious hand to urge them to cease, but this no longer concerns Athena. She is detached, alone, proud and assured of victory. She has overcome the powers of darkness, she has concluded the struggle, and though lesser spirits may still be fighting, she is free and divine, unassailable, immaculate. Even the Nike in her right hand is liberated, the veils have dropped to the ground, naked· and proud she extends her arms, her head thrown back, as much a symbol of victory as the goddess herself.

Gustav Klimt was thiry-five when he and his friends Carl Moll, Josef Hoffmann, Otto Wagner and many others left the Künstlerhaus and founded the Secession, with Rudolf von Alt as its first president. But although Klimt was a gregarious person and one who thought in terms of art policy, as an artist he was always a loner. He had no forerunners, though there were artists he admired – Auguste Rodin and, above all, Max Klinger, Ferdinand Hodler, Jan Toorop, Fernand Khnopff – and he had no successors. His significance lies in his uniqueness, in being a solitary phenomenon. In this sense Gustav Klimt is truly an end and a beginning, but of himself. With him something new entered art, and with his death this came to an end and yielded to something new again, something that, in the person of Oskar Kokoschka, gave twentieth-century art a direction which Klimt could not give though he strongly supported it.

A vital mainspring of his life was his disciplined method of working. His everyday routine was strictly regulated. Early every morning in Vienna Klimt made his way to the Tivoli, a popular café in Schönbrunn, where he breakfasted, until his senses were fully awake, his zeal for work aroused, and his need to paint sufficiently great. He would then take a fiacre to his studio and paint there the whole day. Klimt lived at perpetual high tension. His manner of painting never let him relax. Except for Emilie Flöge he could scarcely bear anyone for any length of time; he was continually engaged in a search and yet supremely concentrated. Society women posed for him in front of the most elaborately arranged backgrounds. Several female models were available to him at all times, waiting in a room next to the studio.

A painter prince? Perhaps. But in a different way to Hans Makart or Franz Stuck. What mattered to him was not over-ornate splendour but clarity and simplicity of space, which he could then populate with figures from his fantasy. Klimt was well read and educated but he was not a man of words. His ideas, therefore, are not found in words but in his pictures.

Anything is model to the painter: landscape, still life, allegory, the human form. When a painter paints human beings, when he makes portraits and counterfeits – is that supreme perfection? In the original Biblical sense it is forbidden to make a likeness of God. Even His name must not be uttered. Spirit is not to be turned into matter through a picture. Spirit has no face, no forceful hands through which creation is performed like those of a peasant who guides his plough and scatters his seed. Spirit is faith, cognition, knowledge, power – but not a picture.

Man, however, evidently cannot endure pure spirit. He was unable to bear paradise either. His need to make himself a 'picture', to turn spirit into matter, mystery into reality, adoration into touch – that need is too powerful and man is too weak to resist the temptation; those with genius succeed in creating art – art as the best proof of God's existence. Here it becomes obvious that art is a necessity, that we could not exist without art, for it is art that gives a name to the unconscious, a shape to the ineffable, and hence

Emilie Flöge at the age of seventeen, pastel 1891, privately owned

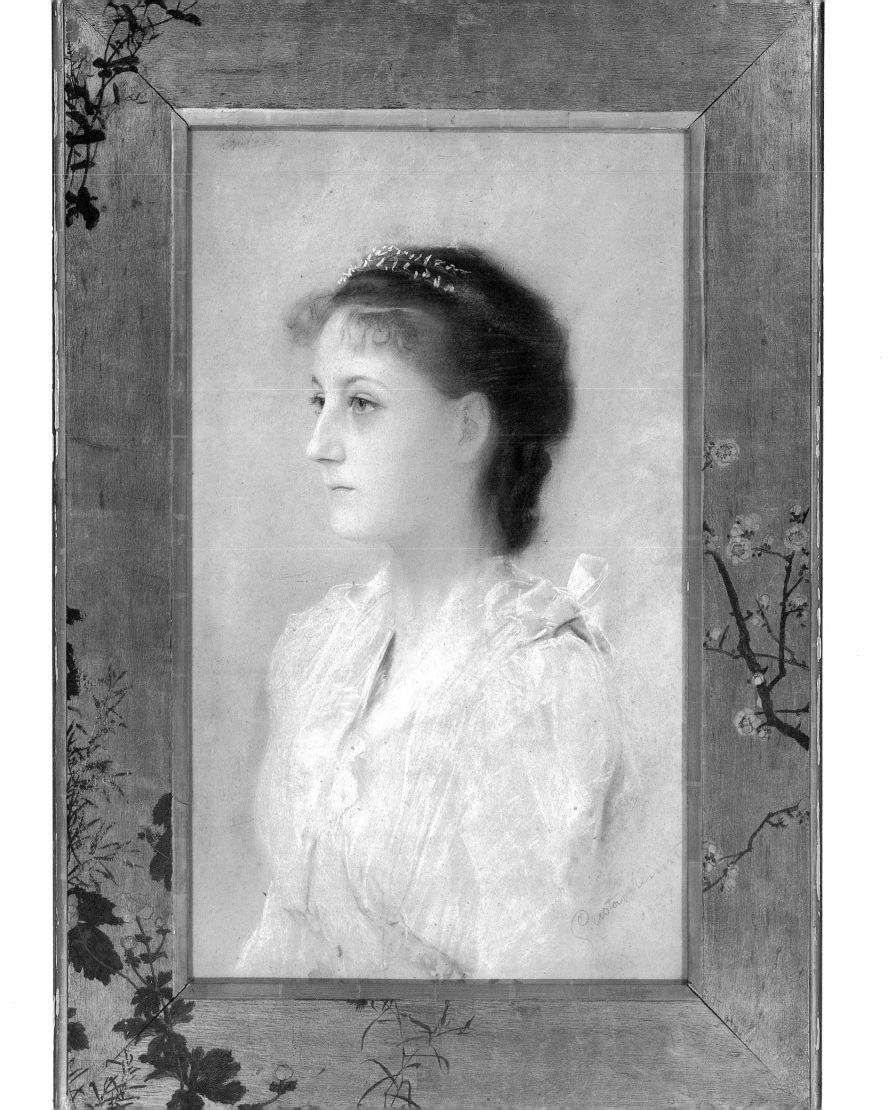

meaning and interpretation to us all. And though, in principle, we may admire the religious restriction which prohibits the making of a picture, since it was that restriction that released other spiritual and creative forces, such as philosophical or contemplative thought and the interpretation of words, our world would nevertheless be very much impoverished without those 'likenesses' – by Raphael, Leonardo, Michelangelo, Rubens, Rembrandt, Goya, Cézanne, or by Klimt.

There has probably never been a painter who has not painted women. Are not nearly all paintings of the Madonna portraits of painters' wives, mistresses, sisters or maidservants? And did not the whole magic of the attraction between the sexes flow into those pictures, the tenderness of the lover, the surrender to the model, even if they were not to become portraits but representations of religious, historical or mythological subjects? If a painter wished to paint women in the nude he resorted to classical or mythological subjects; if he wished to portray the grave dignity of women he painted them as Madonnas or saints. Until the nineteenth century, therefore, the model to the painter was not always a commissioned portrait but the starting point for a composition. And to be painted by Titian or by Goya was an honour. Many a wealthy burgher aspired to being painted by the court painter – that was the next best thing to being an aristocrat. In the nineteenth century portrait painting increasingly became a middle-class affair. Almost anyone could now have himself painted. This was made possible by hundreds of academic painters of varying artistic standards. Having one's portrait painted was part of a refined life-style. And women increasingly went to the artists' studios. It was a taste of a different world: to display oneself was permitted because the justifying goal was art, and the fine clothes, the careful hair style and the sojourn in the artist's studio made sitting for a painter something half-way between a court ball and a bohemian adventure. For hours on end a woman was exposed to the painter's probing glance. With his chalk he explored the contours of her body with greater curiosity and tenderness than her lover might ever do. The line on the canvas was a melting movement, a hitherto undiscovered dimple created intimacy, a slight gesture, a shadow, a rhythmical motion generated tension, and not only in the painting; the wordless dialogue which was conducted here was transformed into colour and shape, into a picture of artistic perfection. Not infrequently did a husband show mistrust upon seeing the finished portrait, upon suddenly realizing, through the delicacy and beauty of the painted woman, the intensity of observation, the passion of painting which the artist had put into the portrait. And he might well jealously ask himself whether that devotion was solely to the picture as an artistic statement or whether that perceptible caress did not include the woman herself – his wife. Berta Zuckerkandl described this in a similar way in 1908:

'It is breath-taking to watch his struggle to express the new knowledge of nature gained during the periods of naturalism and impressionism. This probing and seeking for a higher order, for a more meaningful language of line, this crystallizing emergence of the style. Klimt let all these fermenting forces act upon him. He has been accused of being too readily receptive, too responsive to the perception and manner of expression of strongly individual artists. He simply has the eclecticism of an unflaggingly developing, indefatigably alert mind. He immerses himself in other people's ideas, surrenders to the most heterogeneous impressions, enjoys and extols all beauty. But only in order, through the nourishment thus absorbed, to become ever stronger, ever more individual, ever more creative. Increasingly the spiritual image of the age is reflected in Klimt. His ear catches its most secret signs. Sounds which we cannot yet perceive, lines which we cannot yet discern or feel, vibrations whose twitchings we cannot yet sense – they all strike the artist's innermost nerve. In distant sounds he catches the faintest hint of a new rhythm, one which imparts a bizarre and strange vibration to the senses. This is where the mysterious creative process sets in.

'Klimt paints the woman of his day. The structure of her frame, the contour of her form, the modelling of her flesh, the mechanism of her movements – all these he pursues into the most secret fibres of her being and permanently imprints on his memory. From this safe and solid ground he extemporizes on the subject of woman in all her relations to creation, to nature. Cruelly lustful at one moment and serenely sensual at the next, he paints woman full of mysterious charm. The opalescent flesh tone of her slender body, the phosphorescent sheen of her skin, the square cut of a broad-domed skull and the sinfully red tresses produce an entity of the most profound psychological and pictorial effectiveness. In his portraits he creates nervous, racy female figures, some with a thirst for life, others living in a dream, and all of them, in spite of their characteristic differences, exist by the grace of Klimt. As an ideal figure, however, he dissolves the female body into magnificent decorative lines. Anything accidental, anything individually characteristic, is shed – only the purely typical, the sublimated extract of the modern woman, as the artist has distilled it, remains in the most complete purity of style . . . The sensation of pleasure which outline and brushstroke of colour produce in the soul of the viewer is probably the innermost purpose of decorative painting. The glow, the vibration, the flowing of colours, the veiling, linking, calming atmosphere of brushstroke melting into brushstroke, the music of the hues – all these by themselves, quite separate from the content value of a painting, can produce profound and lasting emotional impressions.'

What is the model to the painter? A mirror image or a mystery

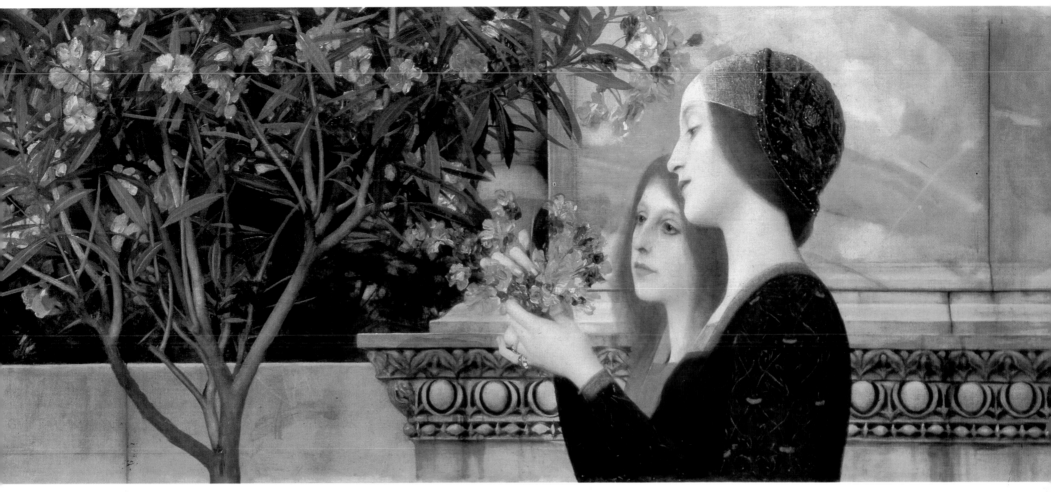

Two girls with oleander, *c.* 1890–2, privately owned, photograph by courtesy of St Etienne Gallery, New York

that must be resolved? 'Painting is my way of thinking', Goya is reported to have said. And even though the painter creates out of his subconscious, it is nevertheless his experience, combined with his skill, that allows the 'form' to emerge from observation and from intuitive knowledge. And woman, what is she to the painter? First, she is a model like anything else – like a landscape or a still life. But she is also more. She is a challenge in her enjoyment and surrender to the moment of being painted, she does not hide but reveals herself as though she were standing alone in front of her mirror, adjusting her pose to the most favourable position – she wants to be beautiful both for herself and for the painter, and of course also for the picture, for the people who will see the picture. Thus she is in harmony with herself, yet at the same time she is on the stage of life. At that particular moment the studio is the stage. The painter is her audience. It is a wordless but clear dialogue – silent agreement in a common desire for perception and form-giving. For all painting is an exploration of laws and rules, an immersion into the strange and the unknown; manifesting this is the truth of art. In every painting, the painter seeks to fulfil a boundless longing for unity, such as existed before man's expulsion from paradise, when man and woman did not yet know each other but were one, an indivisible fruit of one spirit and one will, of one soul. The alienation from intimacy occurred when man was denied an answer to his first tormenting question of 'Why?'. And that 'Why?' has remained our question to this day. We have tried to find answers. Some have turned to art, as one way of getting closer to truth. And he who makes himself silent and receptive, who knows how to listen inwardly while contemplating a work of art, while hearing music or while reading a poem may, at hallowed moments, catch a hint of the answer.

Biography

1862 Gustav Klimt was born on 14 July in Baumgarten, a suburb of Vienna, the second of seven children.
His father, Ernst Klimt (1832–92), was a gold-engraver. He came from a peasant family from Drabschitz (Drabčice) near Leitmeritz (Litoměřice) in Bohemia.
His mother Anna, *née* Finster (1836–1915), a Viennese, came from a humble background.
Of Gustav Klimt's brothers and sisters – Klara, Ernst, Hermine, Georg, Anna and Johanna – two became artists. Ernst shared a studio with Gustav and worked with him until his death. Georg, a sculptor and niellist, subsequently a teacher at the Vienna Art School for Women and Girls, made numerous metal frames for Gustav Klimt's paintings. All the brothers and sisters occasionally acted as models for Gustav Klimt's early works.

1873 World Fair in Vienna. Economic depression, in consequence, the Klimt family faces financial difficulties.

1876 Gustav Klimt is accepted, on a scholarship, to the newly established Kunstgewerbeschule des Österreichischen Museums für Kunst und Industrie (Applied Art School of the Austrian Museum of Art and Industry, now Österreichisches Museum für Angewandte Kunst (the Austrian Museum of Applied Art).
The school is run on the lines of the South Kensington School (later the Royal College of Art) and follows Semper's ideas, which also decisively influenced Otto Wagner.
For two years Klimt attends the preparatory class under Professors Rieser, Minnegerode and Hrachowina, receiving further instruction in painting by Prof. Ferdinand Laufberger (until his death in 1881) and continuing his studies for a further two years under the guidance of Prof. Berger.
The school archives record his attendance at the following courses: '1875–76 Anatomy, History of Styles and Preparatory Class; 1876–77 Technical Drawing; 1878–1879 Specialized Drawing and Painting Class'.

1877 Ernst Klimt is accepted by the Kunstgewerbeschule. He is followed by Georg Klimt. In their free time the brothers draw portraits from photographs. Later drawings occasionally show the same 'photographic naturalism'.

1879 Gustav and Ernst Klimt, together with their fellow student Franz Matsch (1861–1942), are engaged on the execution of Laufberger's graffiti in the courtyards of the Kunsthistorisches Museum (Art History Museum) in Vienna. The three participate in the execution of Hans Makart's festive procession in honour of the imperial couple's silver wedding.

1880 The Klimt brothers and Franz Matsch jointly paint four ceiling panels for the Sturany town house in Vienna. Laufberger recommends them to the theatrical architects Fellner and Helmer. Together they paint a ceiling panel for the Kurhaus in Karlsbad (Karlovy Vary).

1881 Death of Ferdinand Laufberger. Studies continued under Julius Viktor Berger. Commissioned by Martin Gerlach, the publisher, to supply designs for a sumptuous publication of *Allegories and Emblems*. During that year Klimt draws the *The Four Seasons* for that publication.

1882 The Klimt brothers and Franz Matsch work on decorative jobs for Reichenberg (Liberec). Increasing influence of Makart.

1883 The Klimt brothers and Franz Matsch move into a shared studio in Vienna. Various joint commissions, such as ancestral portraits, based on engravings, for the Romanian royal palace in Peleş, Sinaia. For this task Klimt copies Titian.

1884 Marked influence of Makart. Some of the designs for *Allegories and Emblems* reveal the influence of the *quattrocento* (*Youth*), of Michelangelo (*Idyll* and *The Riches of Nature*) and of Max Klinger (*Opera*).

1885 Murals by the studio partnership after designs by Makart for the Hermes Villa in Lainz near Vienna, built by Hasenauer.
Decorative work for the Fiume Municipal Theatre is exhibited in Vienna prior to delivery. Designs for the Bucharest Municipal Theatre.
In one design Klimt for the first time uses gold paint.

1886 Important work by the studio partnership for the Karlsbad (Karlovy Vary) Municipal Theatre built by Fellner and Helmer. Two ceiling paintings by Gustav Klimt; the theatre curtain jointly with Ernst Klimt and Matsch, showing Makart's influence. The 'Klimt Studio' starts on its most important combined task – the ceiling and spandrel paintings for the two staircases of the Burgtheater in Vienna. The programme comprises the history of the theatre. On the right-hand staircase Gustav Klimt painted: *The Chariot of Thespis, Shakespeare's Theatre* and *The Altar of Dionysus*; on the left-hand staircase: *The Theatre in Taormina* and *The Altar of Apollo*. He completed the representation of *Hanswurst improvising* begun by his brother Ernst.
Ernst Klimt and Franz Matsch begin to develop in different directions.

1887 Work on the Burgtheater paintings. Friedrich Pecht sees Klimt as Hans Makart's 'heir'.

1888 Completion of the Burgtheater paintings. Klimt is awarded the highest artistic honour, the Gold Cross of Merit, by the Emperor Franz Joseph.
An idiosyncratic type of naturalism in *Auditorium of the Old Burgtheater, Vienna.*

1889 Paintings such as *Lady with a Lilac Scarf*, with decorative insertion of a gold stripe.

1890 Receives Emperor's Prize (400 Gulden) for *Auditorium of the Old Burgtheater, Vienna.*
Commission by Prince Esterházy for a similar theatre scene. Portrait of the pianist Josef Pembauer in a painted frame with Grecian vase motifs.
Continues Makart's unfinished decoration of the staircase of the Kunsthistorisches Museum in Vienna. Michael Munkácsy paints the ceiling panel and the 'Klimt Studio' paints the forty spandrel and intercolumnar pictures. The eleven spandrel and intercolumnar pictures of Gustav Klimt have as their subject the development of art from ancient Egypt to the *cinquecento*. The figures are mainly represented in strict frontal aspect on a gold ground. First appearance of the *femme fatale* type (*Girl from Tanagra*). Other motifs, subsequently to appear in numerous variations, are first seen here. Gustav Klimt begins to turn away from the academic style.

1891 He joins the Künstlerhausgenossenschaft. Work on the staircase paintings in the Kunsthistorisches Museum. Hermann Bahr publishes *The Overthrow of Naturalism*.

1892 The studio partnership moves into a new studio.
The staircase paintings of the Kunsthistorisches Museum attract considerable attention. The Arts Commission of the Ministry of Education considers inviting the Klimt brothers and Franz Matsch to paint the Great Hall of the University.
Klimt's father dies of a stroke. Ernst Klimt dies on 9 December.

1893 Matsch designs an overall plan for the decoration of the University's Great Hall. Towards the end of the year the Minstry of Education decides that Matsch, together with Klimt, should work out new designs for the Great Hall.
At the Künstlerhaus exhibition Klimt is awarded the Silver State Medal for his *Auditorium of the Theatre in the Esterházy Palace in Totis*. In December Gustav Klimt is proposed, *primo et unico*, for the post of professor of a master class of historical painting at the Vienna Akademie der Bildenden Künste (Vienna Academy of Fine Arts). To the general surprise of the professors the Emperor in 1894 appoints Kasimir Pochwalski.

1894 Gradual dissolution of the studio partnership with Franz Matsch. Portrait of Frau Breunig, a friend of Emilie Flöge, Klimt's common-law wife.
In June/July acceptance of Klimt's and Matsch's designs for the Great Hall of the University. In September they are commissioned to execute sketches for the individual figures. An overall honorarium of 60,000 Gulden is envisaged.
Egyptian Exhibition in Vienna. At the Third International Art Show of the Künstlerhausgenossenschaft Franz Stuck exhibits two landscapes which seem to have impressed Klimt. Fernand Khnopff is awarded the Small Gold Medal.

1895 In Antwerp Grand Prix for Klimt's *Auditorium of the Theatre in the Esterházy Palace in Totis*.
Start on the designs for the new series of *Allegories*. Among Austrian artists collaborating are also other subsequent founder members of the Secession. Klimt's *Love* is a composition in the spirit of Schnitzler, whose *Anatol* was published in 1892.
Liebermann, Whistler, Rops, Thoma and Klinger exhibit at the Gesellschaft für Vervielfältigende Kunst (Society for Reproductive Art) in Vienna. Klinger's invitation to the Vienna Academy is considered. Fierce attack on the Künstlerhausgenossenschaft in a series of articles in *Allgemeine Künstler- und Schriftsteller-Zeitung*, published by Franz Scherer.

1896 In the Künstlerhausgenossenschaft the younger generation, against tough opposition, ensures the award of the Great State Medal to Segantini. Klimt meets Josef Hoffmann at the

'Siebener Club' (Club of Seven). Klimt and Matsch submit their programme design for the arrangement of the ceiling and spandrel panels for the University's Great Hall. Klimt is to paint the ceiling panels *Philosophy*, *Medicine* and *Jurisprudence*, as well as ten spandrel pictures relating to the different faculties. Hints of sexual-demoniac elements, probably after reading Nietzsche.

1897 On 27 March Ludwig Hevesi reports on the foundation of the Vienna 'Secession' (Vereinigung bildender Künstler Österreichs, Association of Austrian Painters and Sculptors), whose members include Engelhart, Moll and Klimt. The Secession is an association within the Genossenschaft bildender Künstler Wiens, the Künstlerhausgenossenschaft. Its aim is the reform of artistic and exhibition practice. It is intended to 'raise Austria's languishing art . . . to the present international level'. On 3 April Klimt officially informs the Committee of Management of the Genossenschaft bildender Künstler Wiens as well as the Viennese press of the foundation of the Vereinigung bildender Künstler Österreichs, i.e. the Secession. The attached list of founder members includes forty names. The President of the Association is Klimt, its Honorary President is Rudolf von Alt. On 22 May, during a tumultuous General Meeting, Klimt along with eight other artists walks out in silence. Two days later he announces his resignation. The first General Meeting of the new association is held on 21 June. It is decided to publish an artistically produced periodical *Ver Sacrum*. Klimt, Josef Hoffmann and Carl Moll are responsible for the exhibitions of the Secession until 1905. Klimt produces a design for the building of the Secession, with the inscription over the doorway '*VER SACRUM Vereinigung bildender Künstler Österreichs*'.
Henceforth Klimt spends the summer months with the Flöge family at Kammer, subsequently also at Weissenbach and some other places on the Attersee and the Wolfgangsee. He paints his first landscapes. Work on the oil sketches for *Philosophy* and *Medicine*. Anatomical studies in the dissection room under Professor Emil Zuckerkandl. His paintings reveal Whistler's influence.

1898 First year of full activity of the Vienna Secession. Publication of the organization's periodical *Ver Sacrum*. For a short period (until 1900) Klimt is a member of the editorial board. Its literary advisers are Hermann Bahr and Max Burckhardt. Numerous, mainly commissioned, contributions by Klimt. March–June: First Exhibition of the Secession on the premises of the Wiener Gartenbaugesellschaft (Vienna Horticultural Society), rearranged by Olbrich and Josef Hoffmann; Klimt designs the poster of *Theseus and the Minotaur* for this exhibition.
Objection by the censor on grounds of 'immorality'; Klimt makes changes to the poster.

Participants of the exhibition include: Brangwyn, Erler, Herterich, Böcklin, Carrière, Mucha, Puvis de Chavannes, Khnopff, Bartholomé, Troubetzkoy, Meunier, Rodin.
At a meeting of the Arts Commission of the Ministry of Education on 26 May Klimt's designs for the faculty paintings are criticized. On the subject of his sketch for *Medicine* 'the wish was mainly expressed for a more decent posture of the female figure representing "Suffering Mankind", a posture less inclined to give rise to objections and obscene jokes, possibly by way of replacing that figure by one of a youth'. Klimt considers resigning the commission. On 3 July, as a result of mediation by Weckbecker, the contract is concluded after all. Klimt and Matsch undertake, 'subject to observation of the limits set by artistic freedom', to make changes to the sketches. Klimt thereupon produces a new, only slightly changed, design for *Philosophy*. Klimt paints his mother and Ernst Klimt's daughter. The picture of Sonja Knips, painted that year, is the first of his large square female portraits. Since April the Secession building has been under construction according to designs by Olbrich. On 12 November the building is opened with the Second Exhibition of the Secession. Objects for exhibition are beginning to be selected with a view to the overall effect. Klimt's *Pallas Athena* arouses violent criticism.

1899 In January the Third Exhibition of the Secession includes Max Klinger's *Christ in Olympus* and pointillist work by Theo von Rysselberghe. Klimt is working on *Philosophy* in a studio specially rented for the execution of the faculty paintings. Completion of the décor for the music room in the Dumba town house and exhibition of *Schubert at the Piano* at the Secession in March. Received with approval. The décor of the Dumba music room, designed by Gustav Klimt and executed by Georg Klimt, shows a certain affinity to the Stuck villa in Munich: Klimt's paintings above the two doors show, in contrast to one another, an 'allegorical' and an 'historical' representation of the theme of music.
Pointillist techique in his landscapes and in *Nuda Veritas*, likewise exhibited in March; it bears as an inscription a distich by Schiller: 'If by your action and your work of art you cannot please everyone – please a few. To please everyone is bad. Schiller. Nuda Veritas.' The motif also seems to have influenced Hodler. For his protrait of Serena Lederer, the wife of August Lederer – to be his most important patron also in the future – Klimt receives a fee of 35,000 Crowns.

1900 In January Japanese Exhibition at the Secession. March to May: Seventh Exhibition of the Secession. *Philosophy* is exhibited 'in uncompleted state' with a short explanatory text: 'Left-hand group of figures: birth, fertility and decline. On the right:

the globe, the cosmic riddle, emerging from below an enlightening figure: knowledge.'

Klimt exhibits his first landscapes. Several works by Jan Toorop. The Exhibition attracts 34,000 visitors. On 24 March eleven professors address a circular letter to the professorial body, urging them to protest against the installation of *Philosophy* in the Great Hall. On 25 March the Board of the Secession protests to the Minister of Education, von Hartel, against the expected protest petition by the professors. Until the end of the month there are numerous press opinions for and against Klimt. The protest against the painting was signed by eighty-seven professors. A counter-declaration was made by twelve professors, including Wickhoff.

At the meeting of the Art Advisory Council of the Ministry of Education on 12 May, presided over by the Minister himself, the professors' protest against Klimt's *Philosophy* is rejected. On 22 May the petition is shelved unanswered.

During the year work on *Medicine*. Landscapes, including sea-scapes. A few graphic contributions to *Ver Sacrum*, including a dedicatory print for Rudolf von Alt, with the text: 'Be true unto yourself and the times will remain true to you.'

In the autumn a World Fair in Paris. The Künstlerhaus participates with fifty-seven works, the Secession with forty-two. Klimt is a member of the hanging committee. His achievements are recognized in the exhibition catalogue. *Philosophy* is awarded the Gold Medal reserved for foreign contributions.

At the end of the year a major exhibition of work by Mackintosh, Macdonald and Macnair at the Secession (Eighth Exhibition). Lively exchange of ideas between the Viennese and the Scottish artists. Josef Hoffmann's influence on Khnopff. Hodler's first visit to Vienna; he is made an Honorary Member of the Secession.

1901 March–May: Tenth Exhibition of the Secession with Klimt's *Medicine*. Violent rejection in the daily press but considerable interest among the public.

On 19 March the Imperial–Royal Public Prosecutor's Office applies for confiscation of the *Ver Sacrum* issue with the sketch designs for *Medicine*. Two days later the application is rejected by the Criminal Bench of the Imperial–Royal Provincial Court.

Wiener Morgen-Zeitung of 22 March 1901 carries a brief statement by Klimt: 'I have no time to get personally involved in this squabble. Besides, I am tired of arguing time and again against the same pig-headed people: when I have finished a picture I don't want to waste several months justifying it to the multitude. What matters to me is not how many people like it but who likes it.'

At the Eighth International Art Exhibition in Munich *Medicine* has a rather cool reception.

Towards the end of the year Klimt is proposed by the assembled professors of the Akademie der Bildender Künste in Vienna to succeed Professor Eduard Lichtenfels, but is not appointed.

The Twelfth Exhibition of the Secession includes numerous works by Hodler, Munch and Toorop; shortly afterwards *Ver Sacrum* devotes a special issue to Toorop.

1902 April–June: Fourteenth Exhibition of the Secession. Symbolist murals and reliefs by various Secession artists are grouped around Max Klinger's statue of Beethoven: the most important attempt by contemporary European art to create a work totally inspired by symbolism. Klimt's contribution to the exhibition: the so-called *Beethoven frieze* in the left-hand hall, with it an explanatory text in the catalogue: 'First long wall facing the entrance: The longing for happiness. The sufferings of feeble mankind: its appeal to the well-armed strong one as an external, and to compassion and ambition as internal driving forces motivating mankind to fight for happiness. Short wall: the hostile powers. The giant Typhoeus, against whom even the gods fought in vain: his daughters, the three gorgons. Disease, madness, death. Debauchery and unchastity, excess. Corroding Grief. Mankind's longings and hopes soar above these. Second long wall: the longing for happiness finds solace in poetry. The arts lead us into the ideal realm, where alone we can find pure joy, pure happiness, pure love. Chorus of angels in paradise. "*Freude, schöner Götterfunke*" ("Praise to Joy, the God-descended"). "*Diesen Kuss der ganzen Welt!*" ("Here's a Kiss to the Whole World!").' Klimt's style based on: a strong emphasis on contours, the placing of the figures full face or in profile, or (following Hodler) parallel to each other. Symbolist formulation of the 'kiss' theme with sun and moon. Numerous polemics in the press. At a sitting of the Budget Commission of the Upper House in May Count Montecuccoli attacks the Secession, Klimt and, in particular, the *Beethoven frieze*.

Klimt paints the portrait of Emilie Flöge and designs clothes for her fashion house. Meeting with Rodin on 7 June in Vienna.

1903 January–February: Exhibition of Impressionists at the Secession (Sixteenth Exhibition). Exhibits include, in addition to the great impressionist painters, also their precursors and numerous post-impressionists such as Cézanne, Van Gogh, Gauguin, Toulouse-Lautrec, Vuillard, Bonnard. Lectures by Richard Muther and Julius Meier-Graefe in connection with the exhibition. The Secession acquires Van Gogh's *Plain of Auvers-sur-Oise*, painted in 1890, and presents the picture to the Modern Gallery. Journey to Ravenna. Start of strongly two-dimensional work with gold paint. Peak of Toorop's influence. Allegorical use of the motif of floating as an expression of 'infinite suffering'; skeletal shapes (*Procession of the Dead*), inspired by Toorop and Minne and

subsequently expressively developed by Schiele. In the summer work on *Hope*. During the year changes to both faculty paintings with a view to achieving a more emphatically two-dimensional form. Until July, and again in the autumn after a summer holiday, work on *Jurisprudence* (in the basic colours of black, red and gold). In May foundation of the Wiener Werkstätte by Josef Hoffmann, Koloman Moser and Fritz Wärndorfer, later much influenced by Klimt. Hodler spends six weeks in Vienna, where he copies the damaged first version of his *The Chosen*. Hodler's growing friendship with Klimt, whose *Judith* he acquires.

November–December: Collective exhibition of eighty of Klimt's works at the Secession (Eighteenth Exhibition). Exhibition rooms decorated by Koloman Moser, the vestibule by Josef Hoffmann. For a poster Klimt designs a variant of *Pallas Athena*. Not many early works are on show, but *Jurisprudence* is exhibited for the first time. On 11 November the Arts Commission of the Ministry of Education views the faculty paintings and subsequently holds a meeting. Positive reception of Klimt's faculty paintings. Because of the difference in quality between Klimt and Matsch it is proposed that Klimt's faculty paintings should be displayed not in the University's Great Hall but in the State Gallery of Modern Art.

'Ver Sacrum' ceases publication at the end of the year.

1904 At the beginning of the year the Secession proposes that Austria's art be represented at the St Louis World Fair by Klimt alone, and in particular by his faculty paintings. Rejection of the proposal by the Ministry of Education. Because of this controversy Austria does not participate in the World Fair. Beginning of tensions within the Secession.

January–February: Nineteenth Exhibition of the Secession. On show are works by Hans von Marées, Edvard Munch, Cuno Amiet, Akseli Gallén-Kallela, Thorn Prikker, Ludwig von Hofmann and, as the centre-piece of the exhibition, thirty-one works by Hodler, whose design is used for the exhibition poster. One-month stay in Vienna by Hodler and Amiet.

Klimt participates in exhibitions in Germany: at the Great Art Exhibition in Dresden eight of his paintings are shown, including *Gold Fish* and *The Golden Knight* (*Life, a Struggle*); at the Munich Secession (First Exhibition of the Deutscher Künstlerbund, the German Artists' League) his *Procession of the Dead*.

Joseph Hoffmann is commissioned to build a town house for the Belgian industrialist Adolphe Stoclet. Klimt is commissioned to design the dining-room frieze, to be executed as a mosaic. Klimt is also commissioned to provide the décor (though this never materialized) for a theatre in Paris, to be built by J. M. Olbrich for Felix Rappaport, the former editor of *Wiener Rundschau*. Klimt resigns his commission for the ten spandrel paintings for the Great Hall of the University.

Cézanne and Beardsley at the Miethke Gallery in Vienna; Klimt admires both artists.

The year probably marks the beginning of regular nude drawings of several professional models simultaneously present at Klimt's studio.

1905 On 3 April Klimt writes to the Ministry of Education, resigning his commission for the faculty paintings.

In May he exhibits 15 paintings at the Second Exhibition of the Deutscher Künstlerbund in Berlin, including, for the first time, *Hope* and *The Three Ages of Woman*. In Berlin he meets Hodler and, jointly with Hodler and Hübner, receives the 'Villa Romana Prize' but cedes it to Max Kurzweil.

Klimt's appointment as professor, proposed by the Akademie der Bildenden Künste, is definitively rejected by the Ministry of Education, allegedly upon objection by the Archduke Franz Ferdinand. Bertold Löffler is appointed instead. Growing tensions in the Secession. Carl Moll, the artistic adviser of the Miethke Gallery, is attacked in the Secession; Klimt and his friends, the 'stylists', take this as the occasion for leaving the Secession.

The first large female portraits with pseudo-architectural backgrounds (portrait of Margaret Stonborough-Wittgenstein). In a letter discussing these Klimt refers to his 'pathological reluctance to write'.

1906 In connection with the Stoclet frieze Klimt travels to Brussels and subsequently to London. Foundation of the Österreichischer Künstlerbund (Austrian Artists' Union); (Klimt was to become its president from 1912 onward). Portrait of Fritza Riedler, the first square portrait of his 'golden period'.

Development of the pseudo-sculptural motifs in the Stonborough-Wittgenstein portrait into montage-like elements introduced into the surface of the picture.

1907 Final changes to the faculty paintings.

First exhibition of the definitive versions of the faculty paintings at the Miethke Gallery in Vienna and at the Keller und Reiner Gallery in Berlin. Participation in the International Art Exhibition in Mannheim.

Peak of the 'golden period'. Portrait Adele Bloch-Bauer I. Restraint in the use of deliberately shocking abstract motifs (as revealed by a comparison of *Hope II* with the first version of the subject). Appearance of peculiar oval pictorial ornaments. Strongly two-dimensional organization of the picture space also in his garden paintings. Symbolist landscape motifs (*The Sunflower*). During the year Egon Schiele makes personal contact with Klimt.

1908 *Jurisprudence* and other paintings exhibited in Prague in the spring. In summer inauguration of the Vienna Art Show 1908. This is the first public manifestation of the 'stylist' group who left the Secession in 1905, then often called the 'Klimt group'. Temporary exhibition building (on the plot where the Vienna Konzerthaus would subsequently be built) by Josef Hoffmann in co-operation with Alfred Roller and Emil Hoppe. The original inscription of the Secession building, 'To the age its art, to art its freedom', is placed above the entrance.

Klimt exhibits sixteen pictures, including his major recent works, and gives the opening address. The Österreichische Staatsgalerie acquires the central item of the exhibition, Klimt's *Kiss*. First exhibition of the young Oskar Kokoschka.

1909 In the summer Vienna Art Show 1909 in the building of the 1908 Art Show; after this second exhibition the building is pulled down. Klimt, president of the Art Show, exhibits *Judith* and *Old Woman*.

The Wiener Werkstätte start work on the mosaics for the Stoclet town house under Klimt's supervision.

In October, journey to Paris.

With Faistauer and others Schiele founds the Neukunstgruppe (New Art Group). Postcard design by Schiele: *Two monks with haloes*; in this drawing Schiele is showing a sketch to Klimt who regards it with a benedictory gesture. Klimt participates in the Tenth International Art Exhibition in Munich and in the Eighteenth Exhibition of the Berlin Secession.

1910 Successful participation in the Ninth Biennale in Venice. Alongside paintings in the 'golden style' some more recent work, such as *Mother with Children* and *The Black Feathered Hat*. Impressions of Paris are reflected also in some new landscapes.

Participation in the exhibition of the Deutscher Künstlerbund in Prague and in the exhibition 'Art of Drawing' of the Berlin Secession. In Vienna, exhibition without catalogue, mainly of drawings, at the Miethke Gallery.

1911 Participation in the International Art Exhibition in Rome. First Prize (jointly with Zuloaga and Szinyei Merse) for *Death and Life*. Journey to Rome.

Stoclet frieze placed in position in Brussels. Journey to Brussels with Fritz Warndorfer, subsequently to London and Madrid. Klimt moves into a new studio in Vienna, Unter-St Veit; he decorates its entrance with two sculptured heads made by him for the purpose.

1912 *Portrait Adele Bloch-Bauer II*, the first strongly decorative frontal female portait of Klimt's late period.

Participation in the Great Art Exhibition in Dresden.

Article on Klimt by Arpad Weixlgärtner in *Graphische Künste*. Josef Hoffmann founds the *Österreichischer Werkbund* (Austrian Work Association). Egon Schiele paints *Cardinal and Nun*, an expressive companion piece to Klimt's *Kiss*, as well as *The Hermits* which show him together with Klimt.

1913 In March, exhibition of the Bund Österreichischer Künstler in Budapest, Müvézház, with Klimt showing ten paintings and ten drawings.

Completion of the *Virgin* and its exhibition at the Eleventh International Art Exhibition in Munich. Participation in the exhibition of the Kunsthalle Mannheim (Third Exhibition of the Deutscher Künstlerbund).

Summer on Lake Garda.

Together with Rudolf Jung, Josef Hoffmann and Carl von Reininghaus, Klimt is a member of the jury for the art prize endowed by Carl von Reininghaus. As president of the Bund Österreichischer Künstler Klimt informs Schiele of his admission to the association.

1914 Exhibition of some work in the Deutscher Künstlerbund in Prague. Outbreak of First World War in the summer.

1915 Temporary abandoning of strong colour. Two portraits in green and grey tones: those of Barbara Flöge, the mother of Emilie Flöge, and of Charlotte Pulitzer, the mother of Serena Lederer.

1916 Participation in the exhibition of the Bund Österreichischer Künstler at the Berlin Secession, together with Schiele, Kokoschka and Faistauer.

1917 In the spring, journey to northern Moravia. Summer holiday in Mayrhofen (Tyrol).

Small-format female portraits with more immediate psychological expression.

The Akademie der Bildender Künste in Vienna as well as the Akademie der Bildender Künste in Munich elect Klimt an Honorary Member. On 12 September Peter Altenberg writes his 'Address' to Klimt.

1918 After Christmas 1917 journey to Romania. Following his return to Vienna Klimt suffers a stroke on 11 January. He dies on 6 February. Schiele sketches him in the morgue of the Vienna General Hospital. Burial at the Hietzing cemetery in Vienna.

Otto Wagner, Ferdinand Hodler, Kolo Moser and Egon Schiele all die in the same year. End of First World War.

PLATES

PLATE 1

Love, 1895
Oil on canvas, 60 × 44 cm
Inscribed b.r.: GUSTAV KLIMT MDCCCVC
Historisches Museum der Stadt Wien

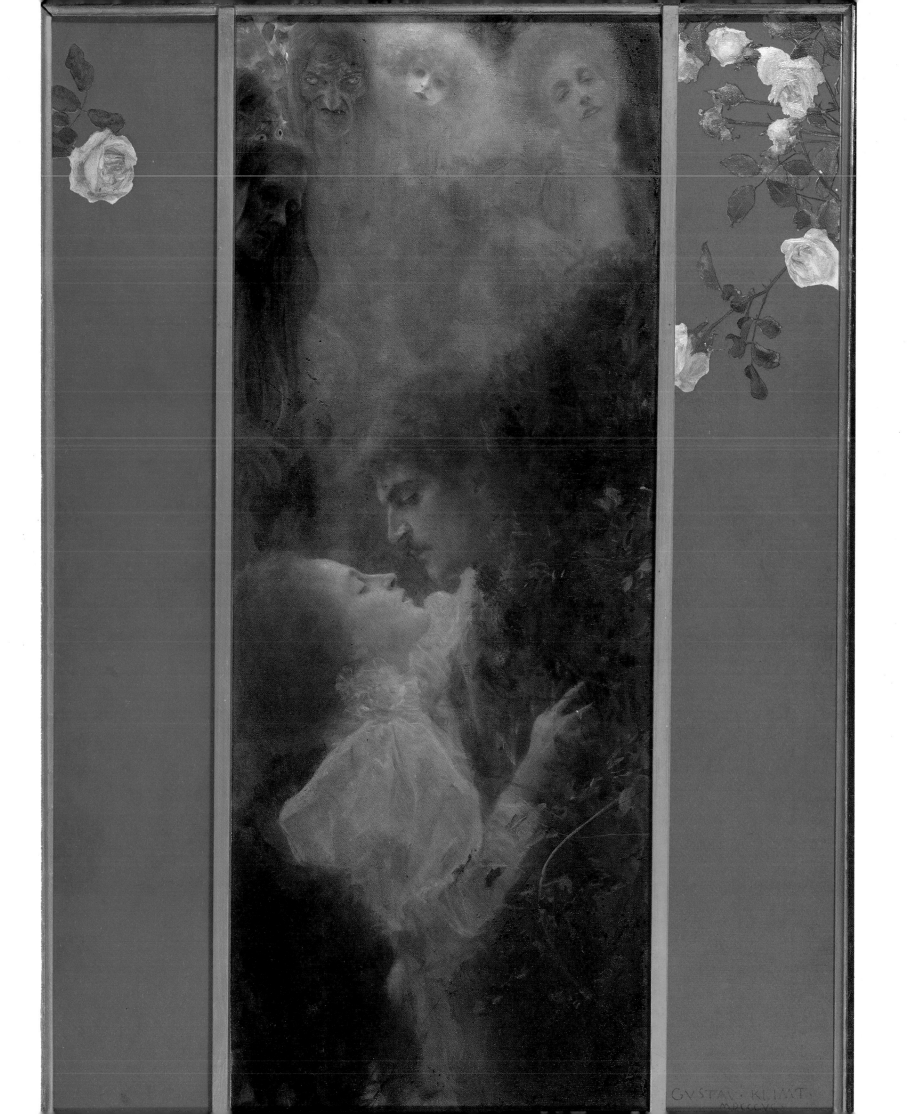

PLATE 2

Music I, 1895
Oil on canvas, 37 × 44.5 cm
Inscribed b.l.: GUSTAV KLIMT 95
Bayerische Staatsgemäldesammlungen (Neue Pinakothek), Munich

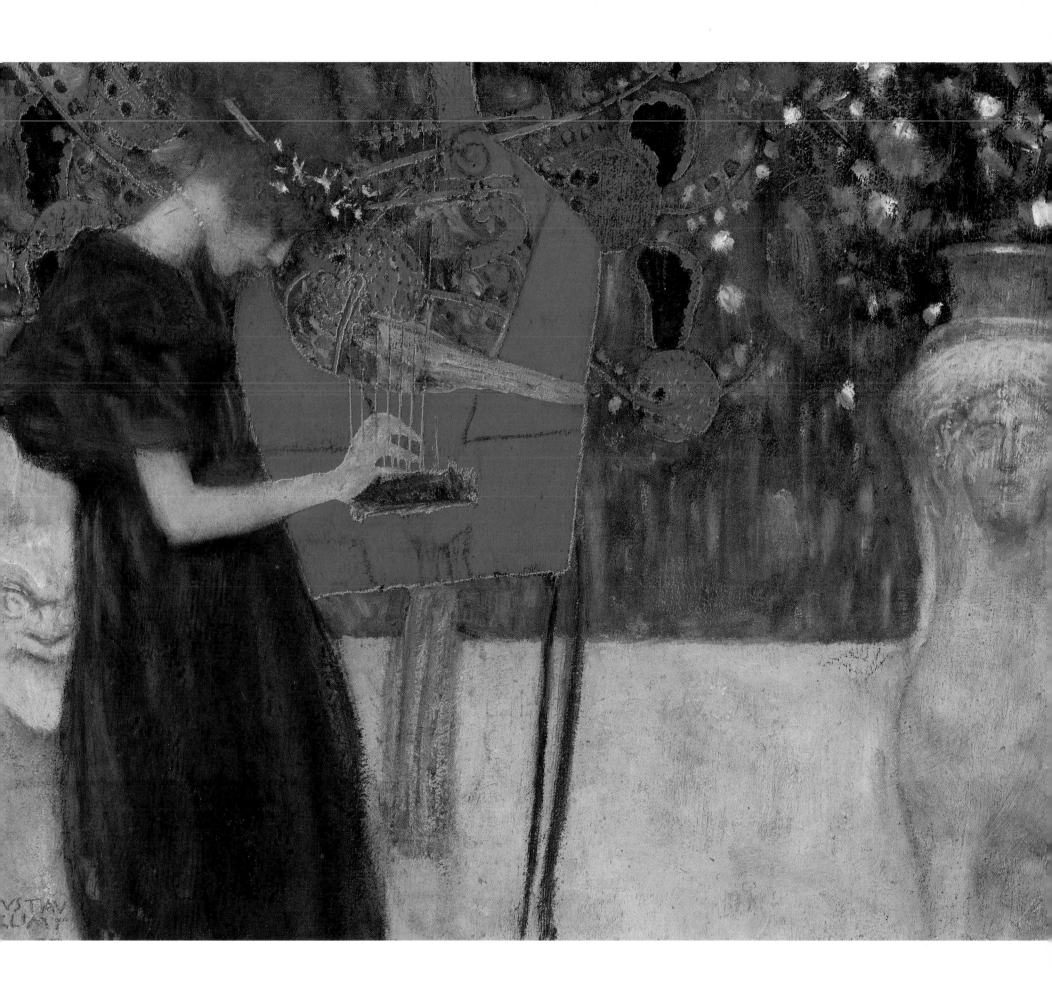

PLATE 3

Sonja Knips, 1898
Oil on canvas, 145 × 145 cm
Inscribed b.r.: GUSTAV KLIMT
Österreichische Galerie, Vienna

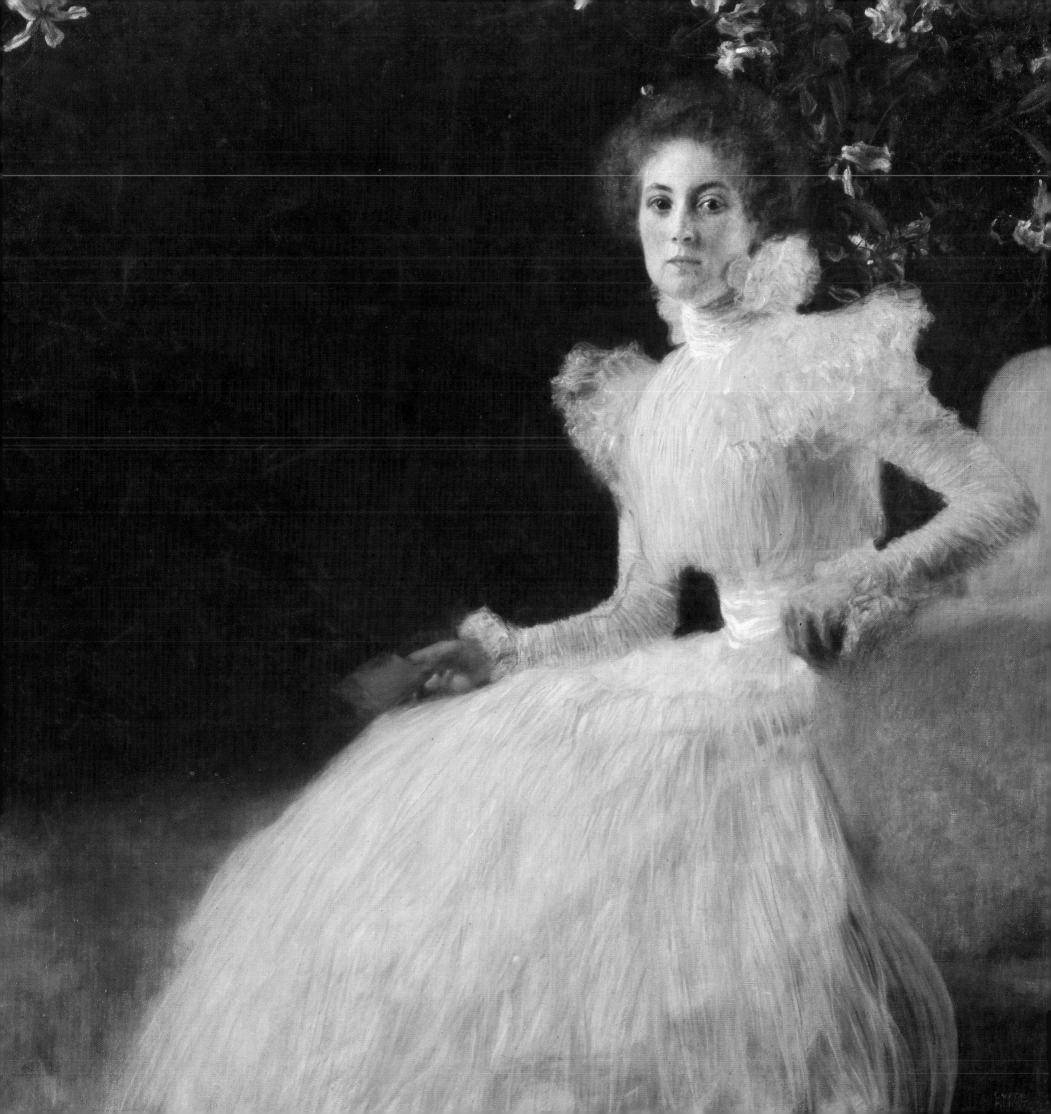

PLATE 4

Helene Klimt, 1898
Oil on cardboard, 60 × 40 cm
Privately owned

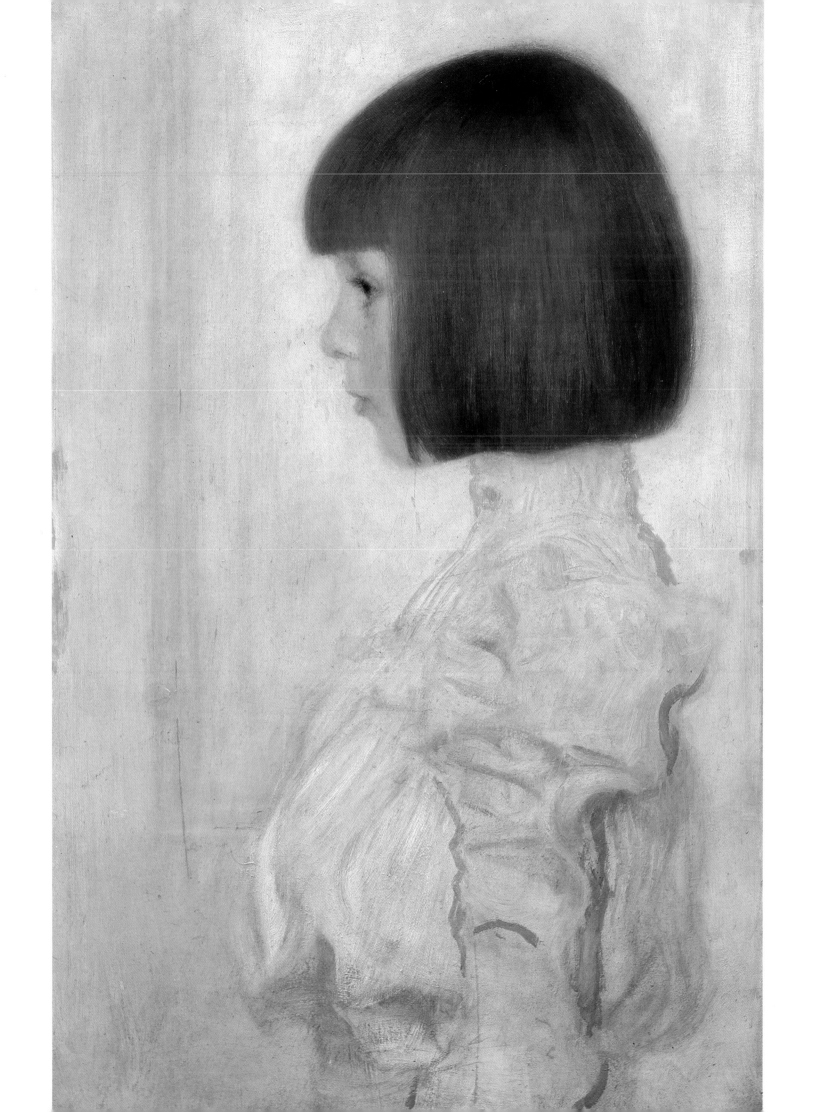

PLATE 5

Pallas Athena, 1898
Oil on canvas, 75 × 75 cm
Inscribed t.l.: GUSTAV KLIMT 1898
Historisches Museum der Stadt Wien

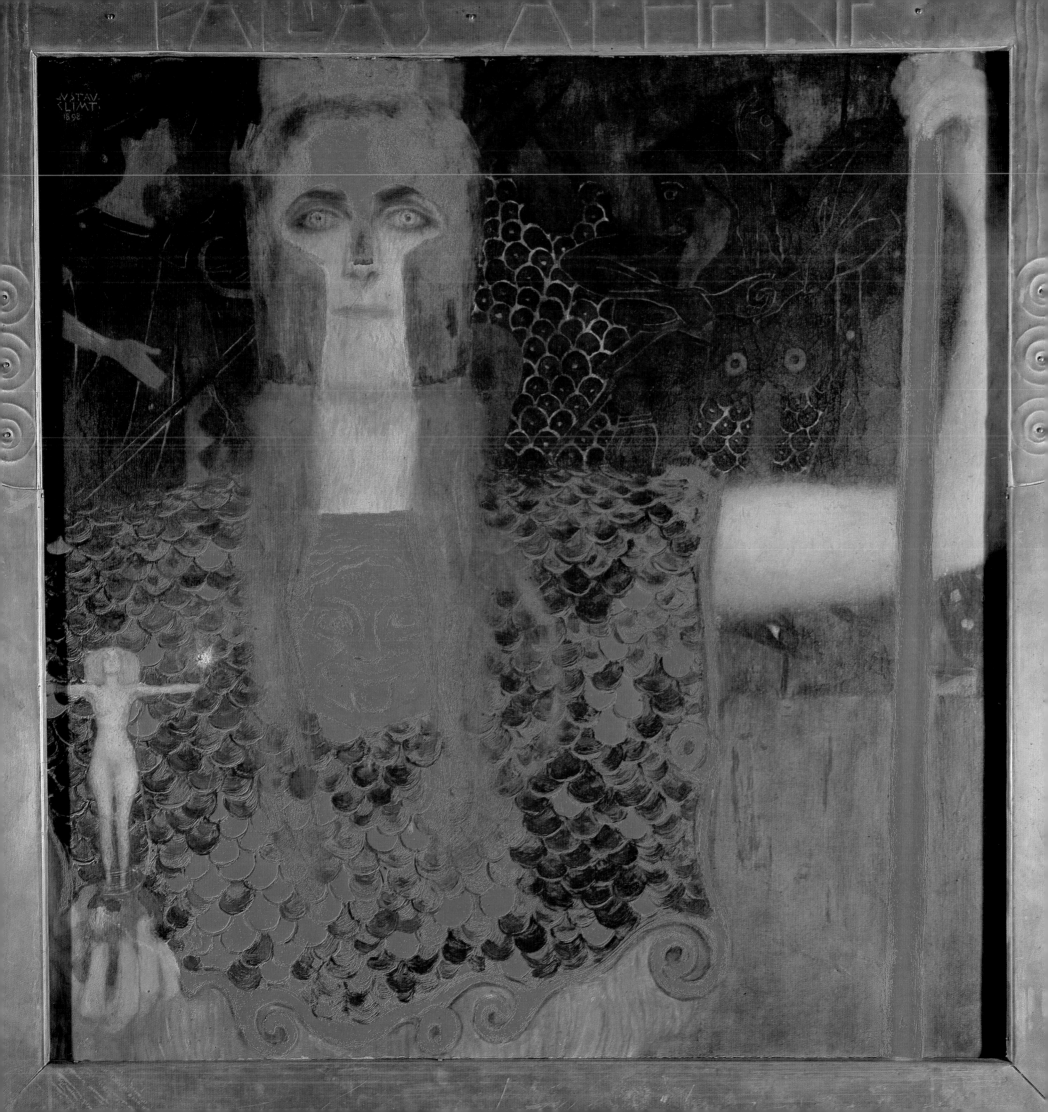

PLATE 6

Moving Water, 1898
Oil on canvas, 52 × 65 cm
Inscribed b.r.: GUSTAV KLIMT
Privately owned; photograph by courtesy of St Etienne Gallery, New York

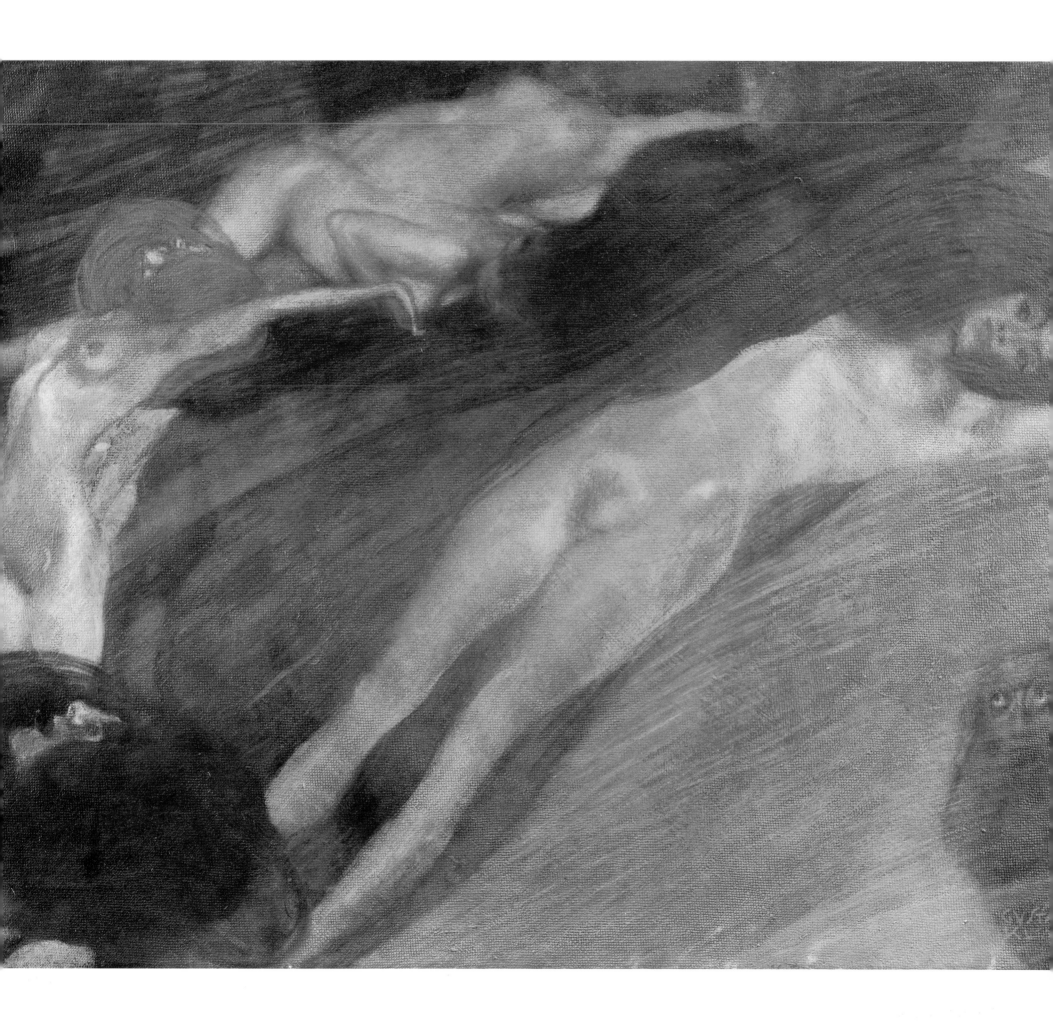

PLATE 7

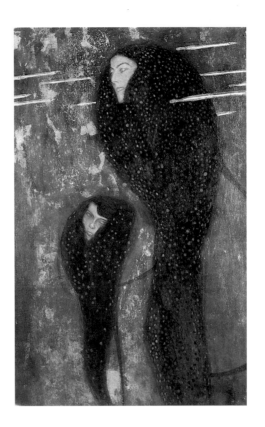

Water Nymphs (Silver Fish), *c.* 1899
Oil on canvas, 82 × 52 cm
Inscribed b.l.: GUSTAV KLIMT
Zentralsparkasse der Gemeinde Wien

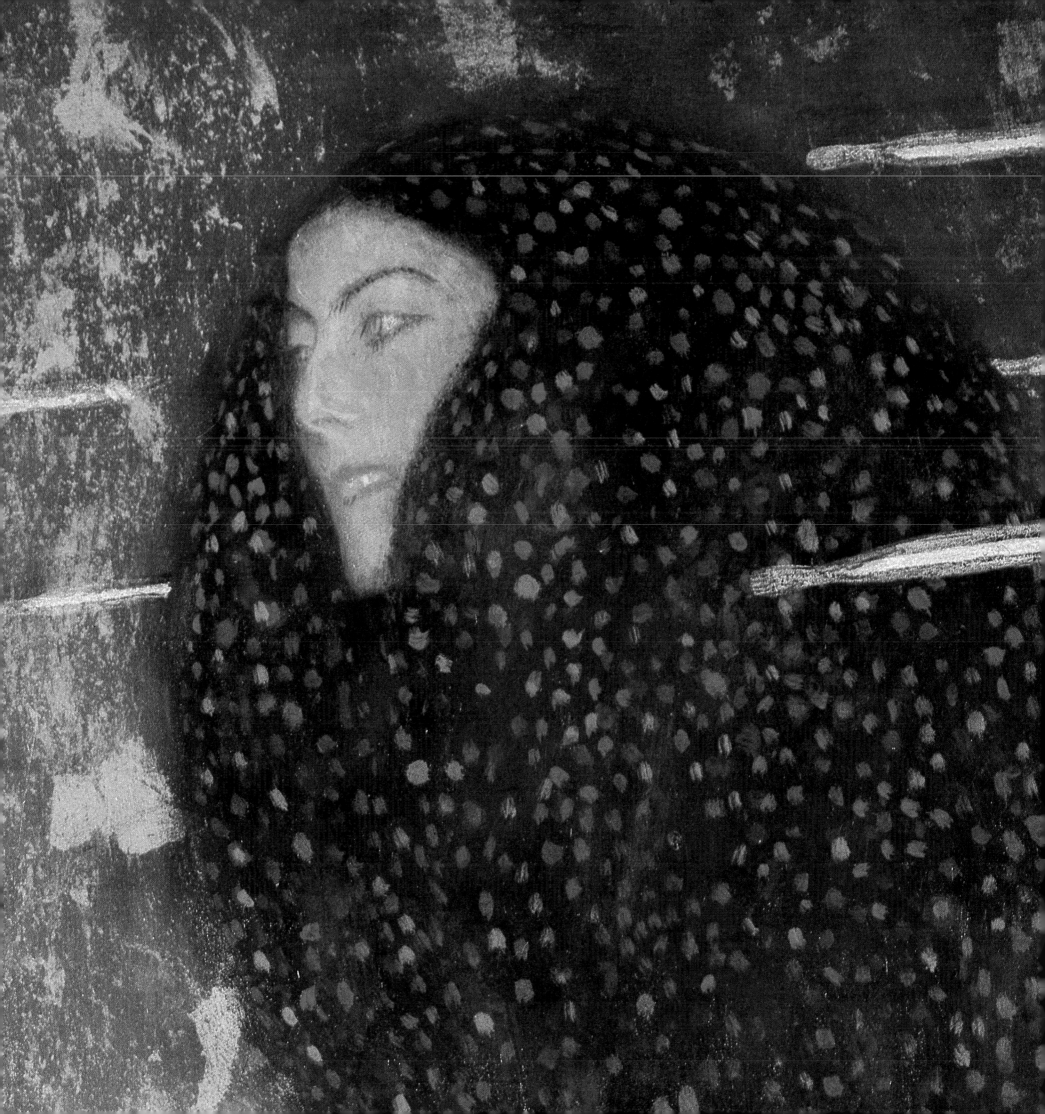

PLATE 8

Full-Face Head of a Girl, 1898
Oil on cardboard, 38 × 43 cm
Privately owned

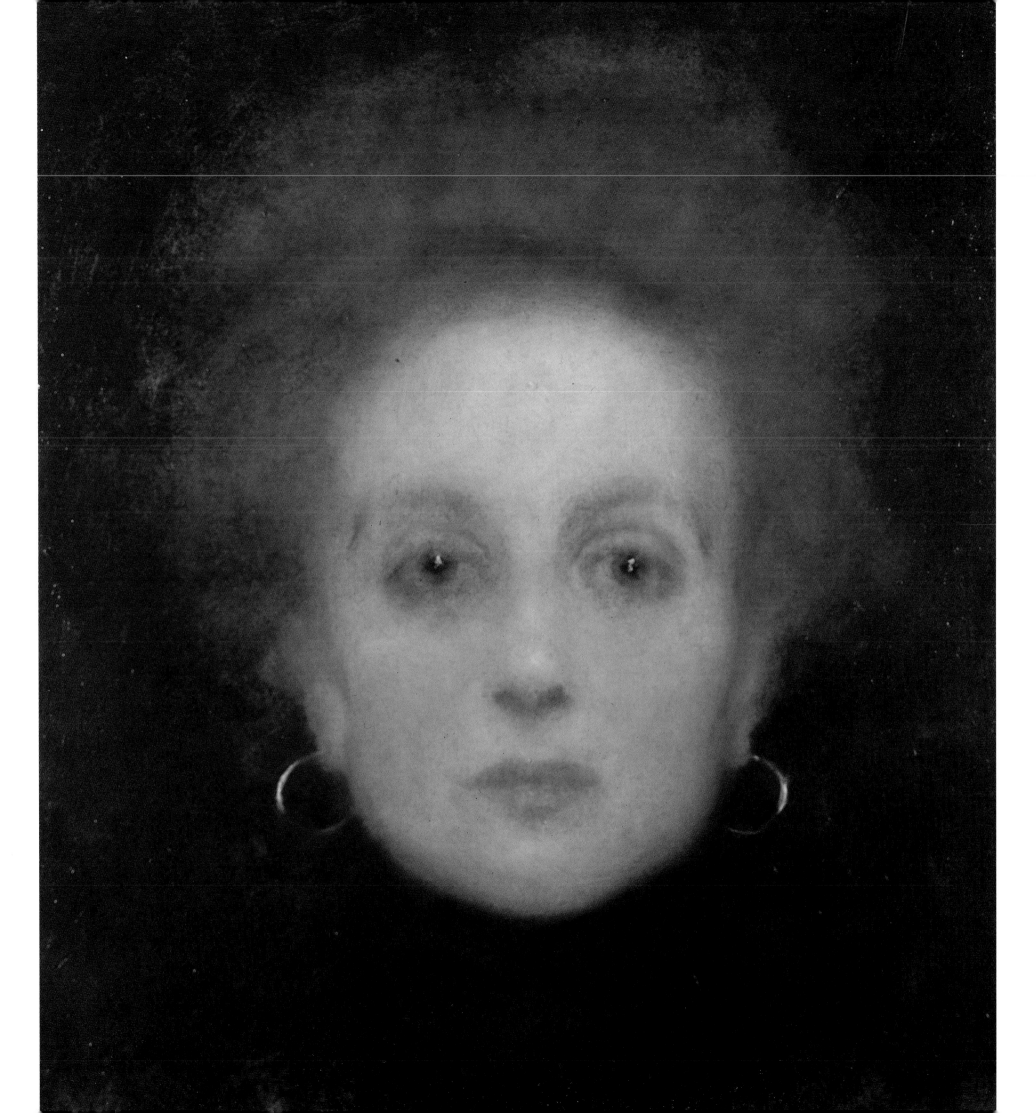

PLATE 9

Full-Face Portrait of a Lady, *c.* 1898–9
Oil on cardboard, 45 × 34 cm
Inscribed b.r.: GUSTAV KLIMT
Österreichische Galerie, Vienna

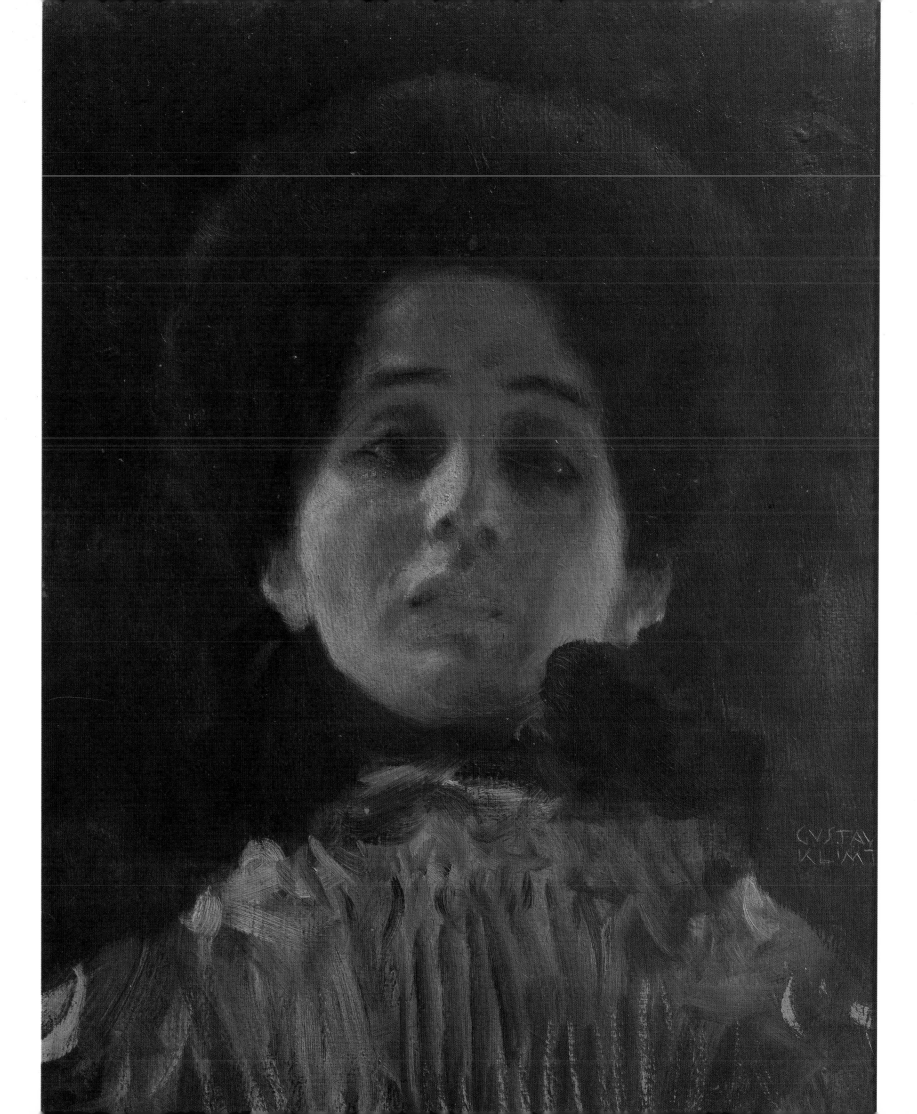

PLATE 10

Schubert at the Piano, 1899
Painting in the music room of the Dumba town house
Oil on canvas, 150 × 200 cm
Inscribed c.r.: GUSTAV KLIMT
Destroyed by fire in 1945

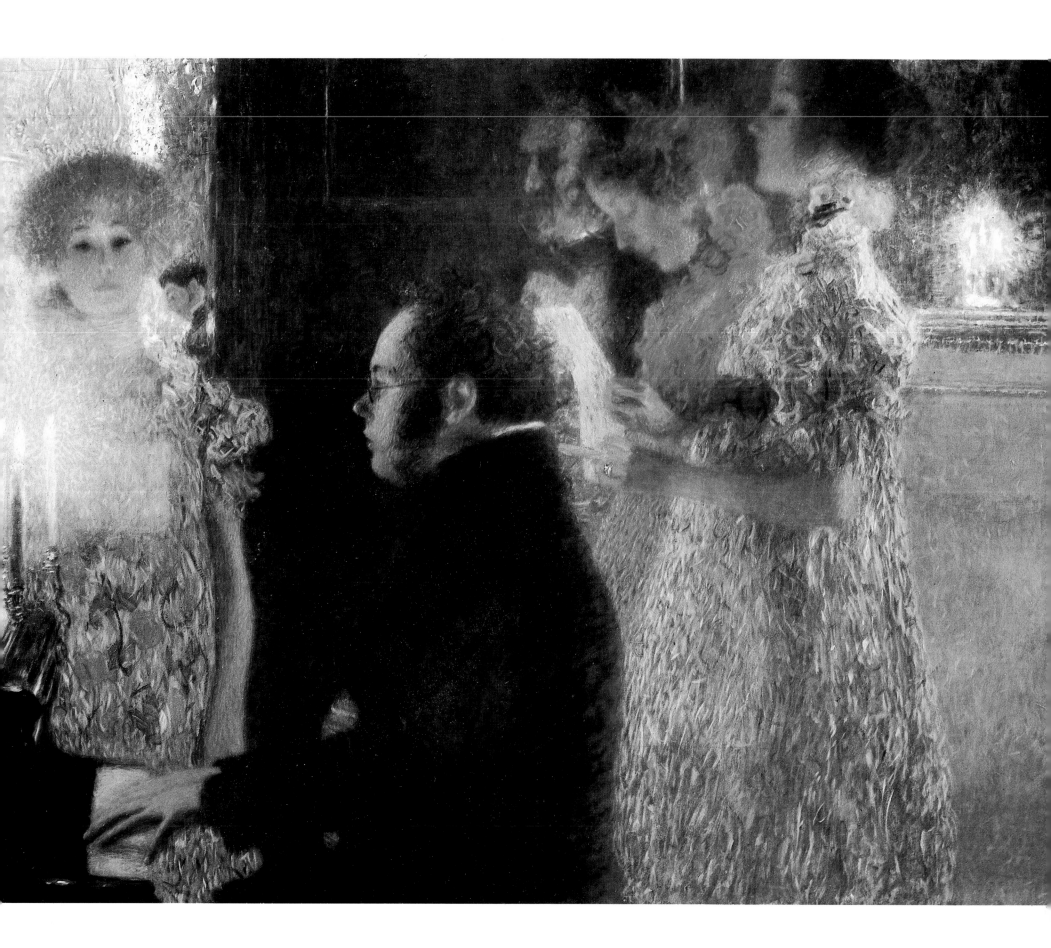

PLATE 11

Serena Lederer, 1899
Oil on canvas, 188 × 83 cm
Inscribed b.r.: GUSTAV KLIMT
Lederer collection, Geneva

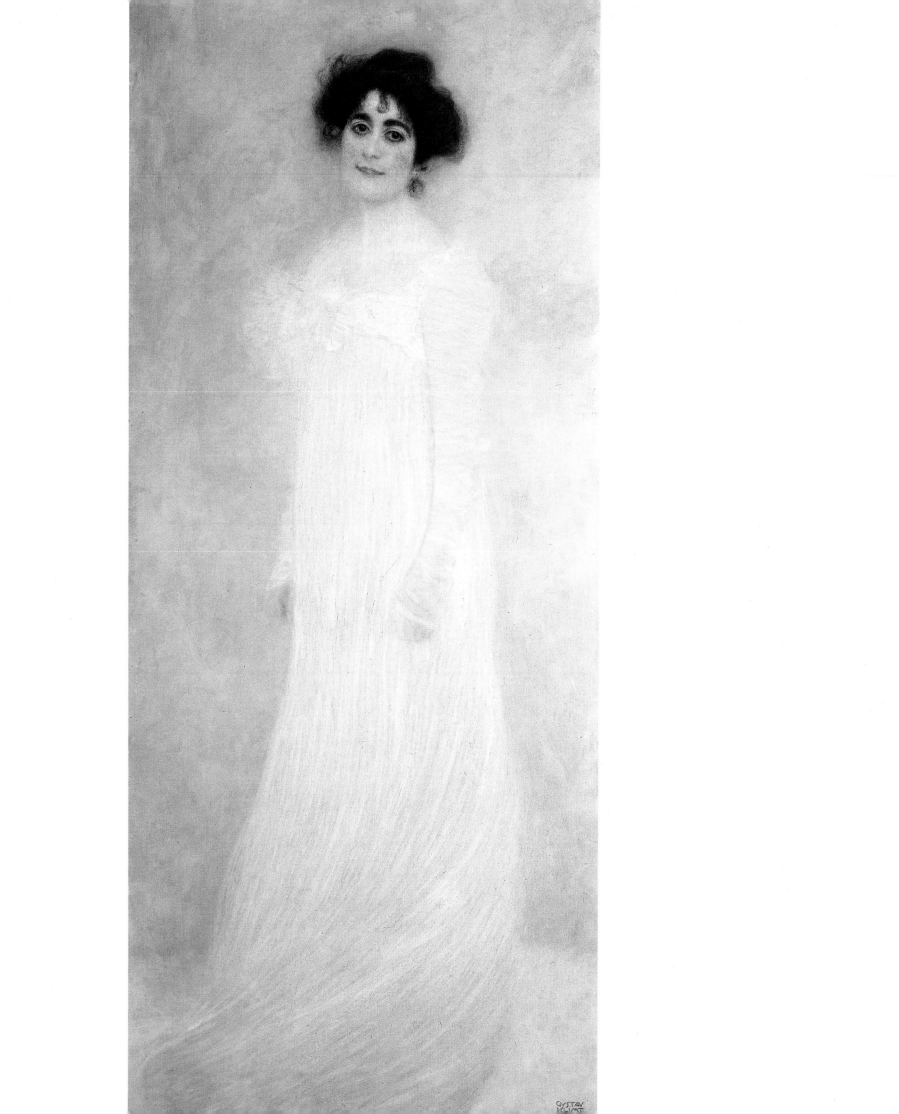

PLATE 12

Nuda Veritas, 1899
Oil on canvas, 252 × 56.2 cm
Inscribed b.r.: GUSTAV KLIMT
Theatersammlung der Nationalbibliothek Wien

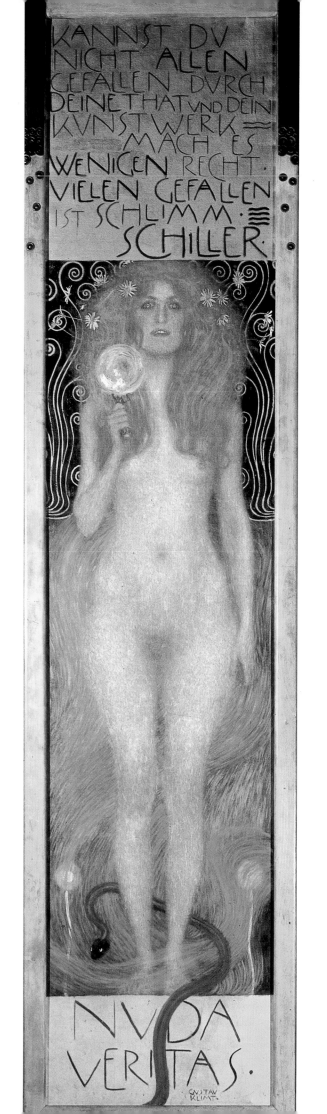

PLATE 13

Medicine (Study), 1897–8
Oil on canvas, 72 × 55 cm
Privately owned, Vienna

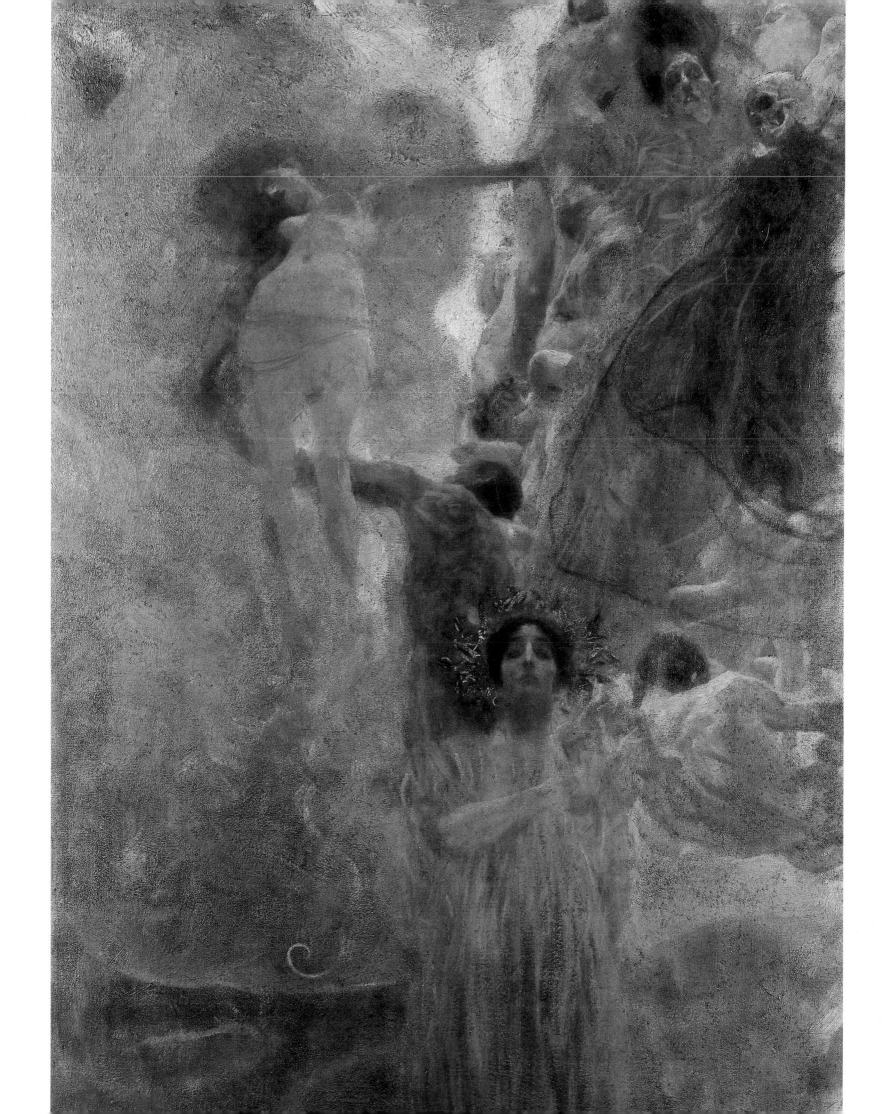

PLATE 14

Hygieia (Detail from *Medicine*), 1900–7
Oil on canvas
Destroyed by fire in 1945

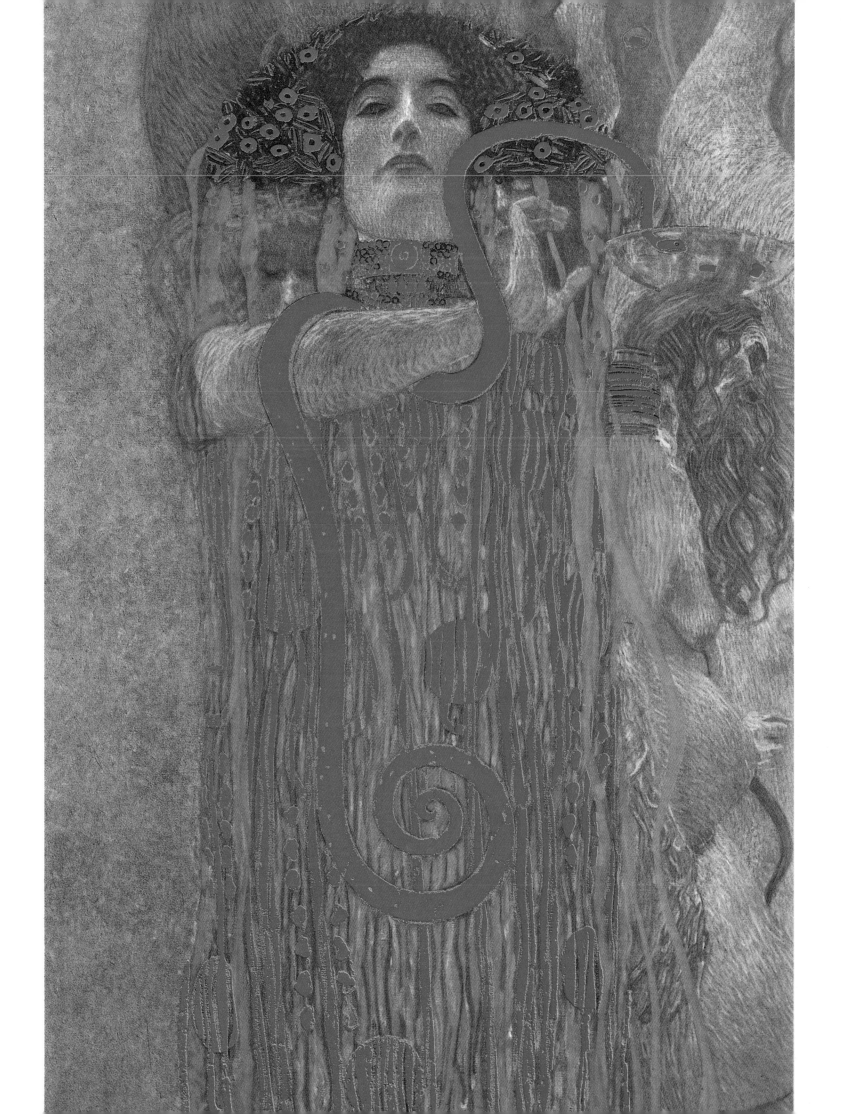

PLATE 15

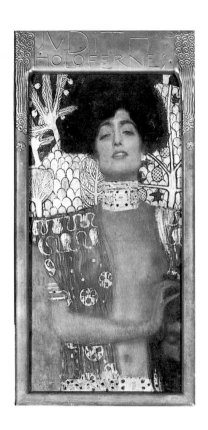

Judith I, 1901
Oil on canvas, 84 × 42 cm
Inscribed b.l.: GUSTAV KLIMT
Österreichische Galerie, Vienna

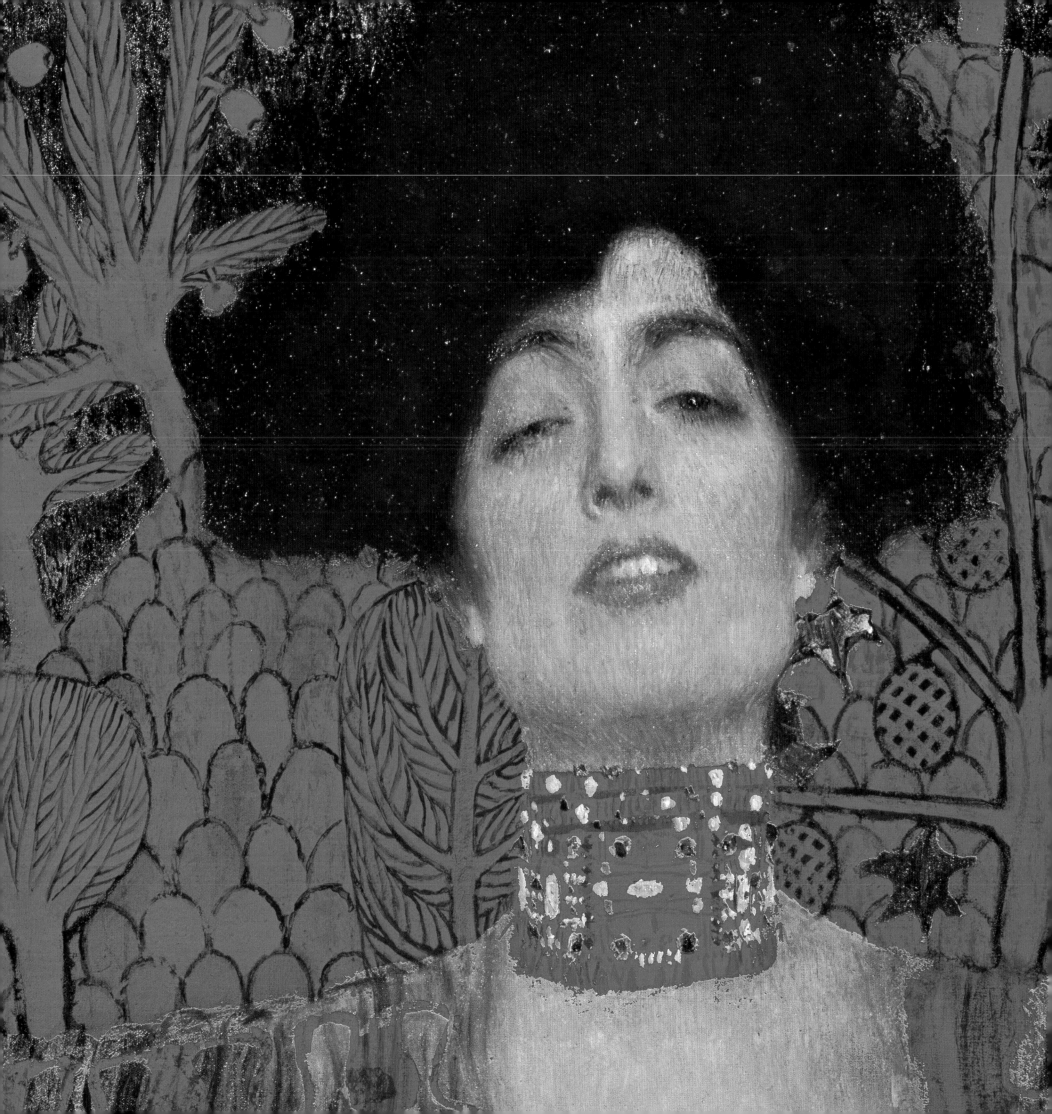

PLATE 16

Goldfish, 1901–2
Oil on canvas, 181 × 66.5 cm
Inscribed b.r.: GUSTAV KLIMT
Kunstmuseum Solothurn (Dübi-Müller Foundation)

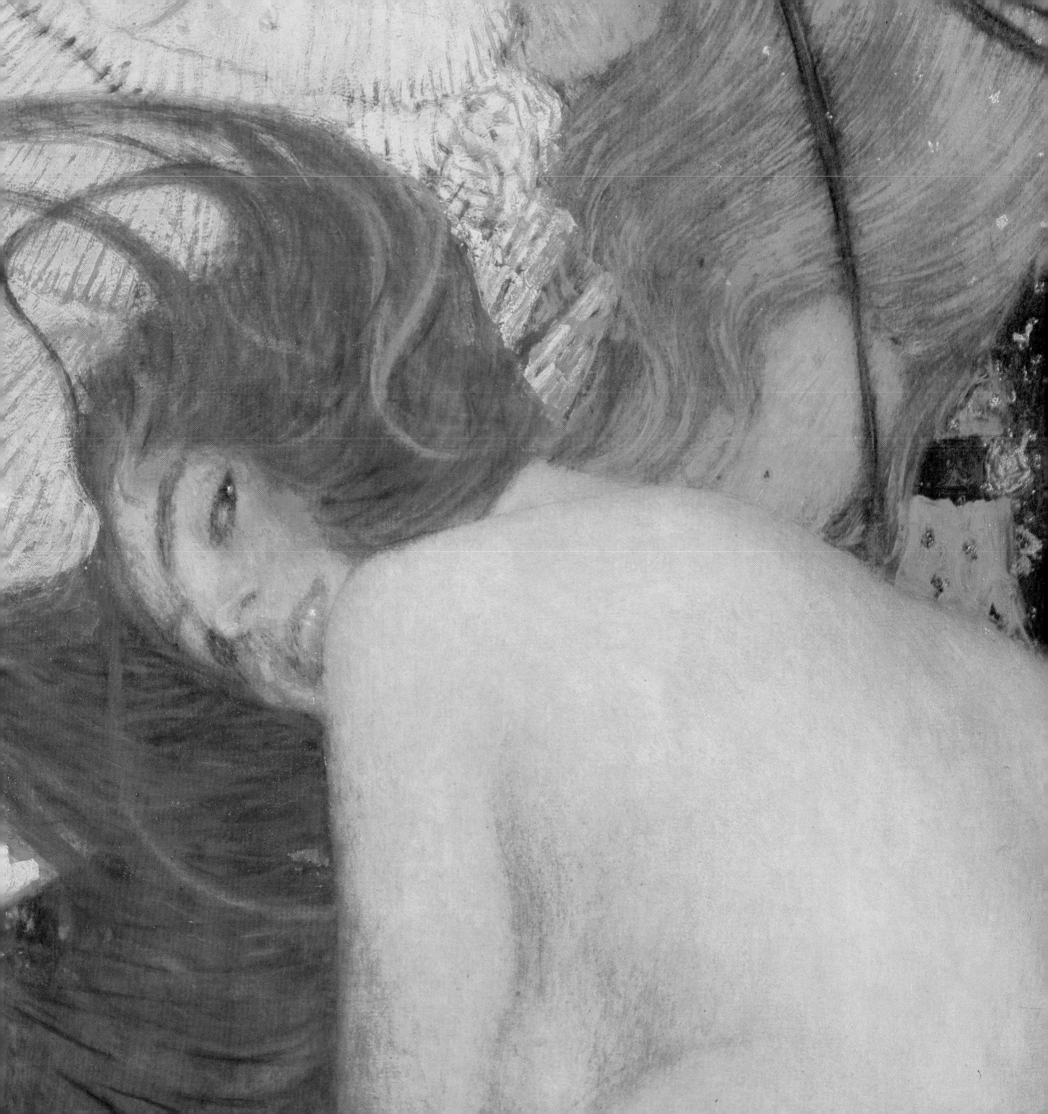

PLATE 17

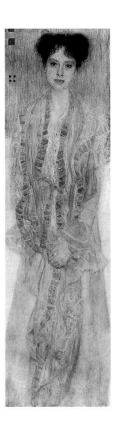

Gertha Felsöványi, 1902
Oil on canvas, 150 × 145.5 cm
Inscribed t.l.: GUSTAV KLIMT 1902
Privately owned

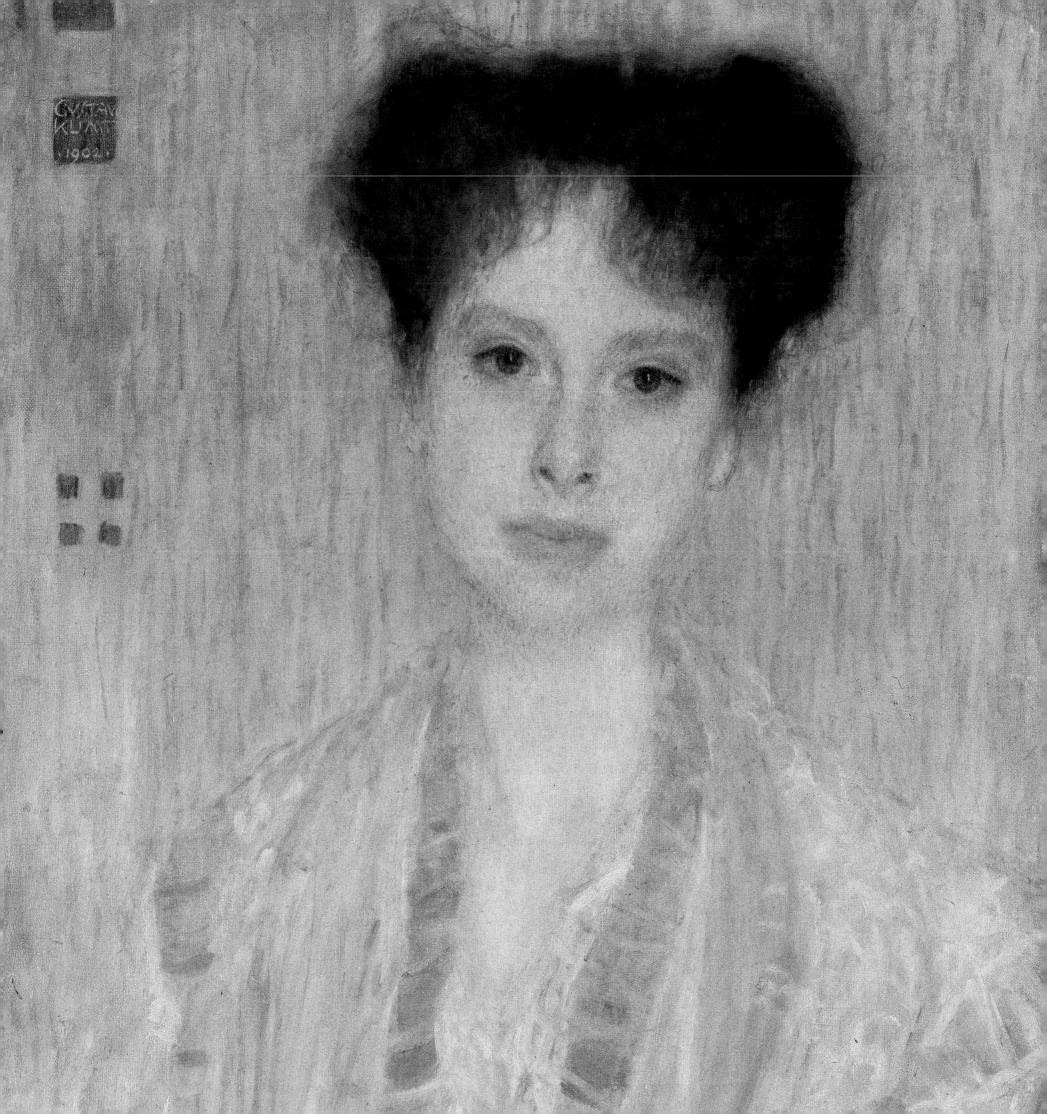

PLATE 18

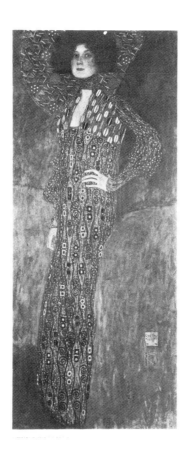

Emilie Flöge, 1902
Oil on canvas, 181 × 84 cm
Inscribed b.r.: GUSTAV KLIMT 1902
Historisches Museum der Stadt Wien

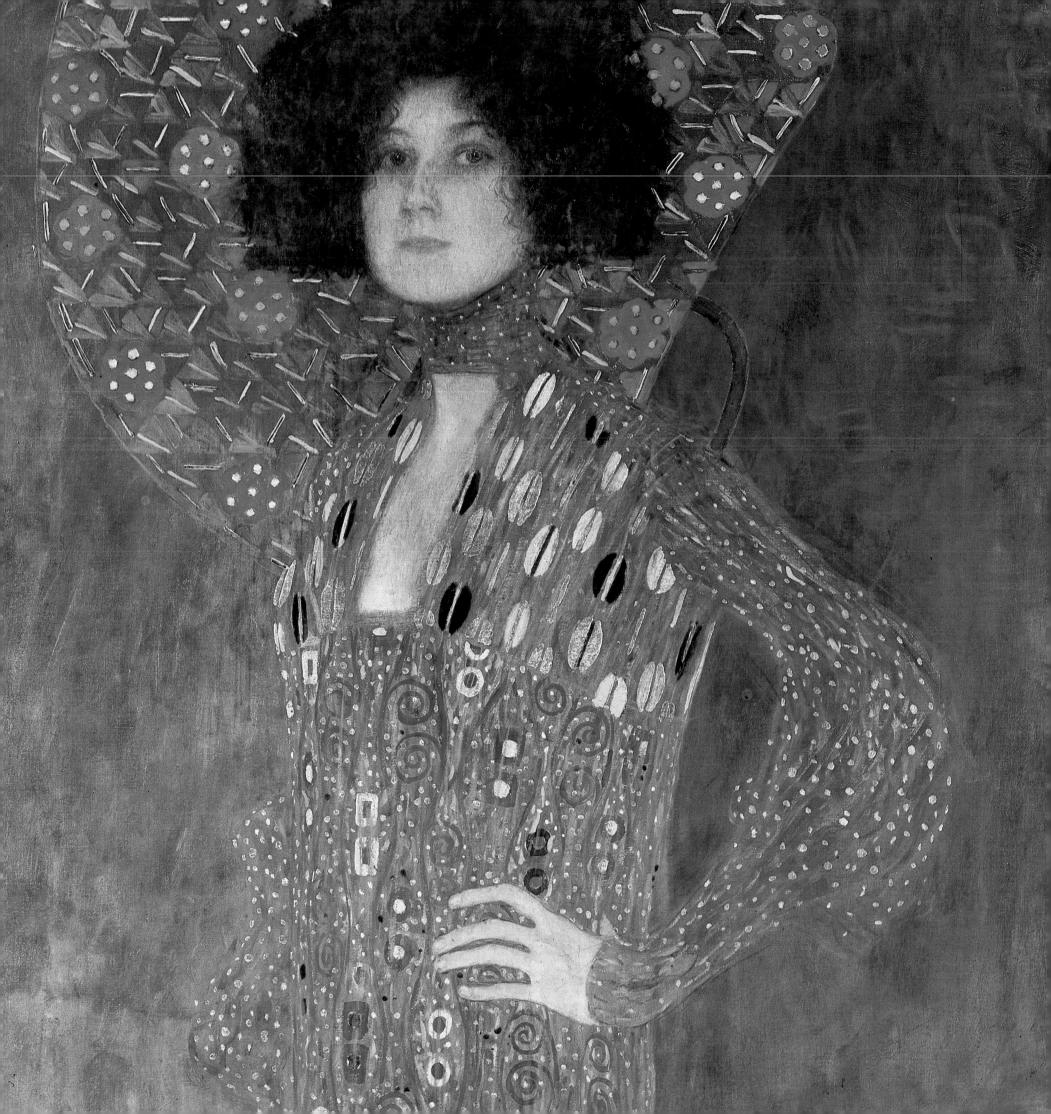

PLATE 19

Girl from the Beethoven frieze, 1901–2
(*'The Sufferings of Feeble Mankind'*)
Casein on stucco
Österreichische Galerie, Vienna

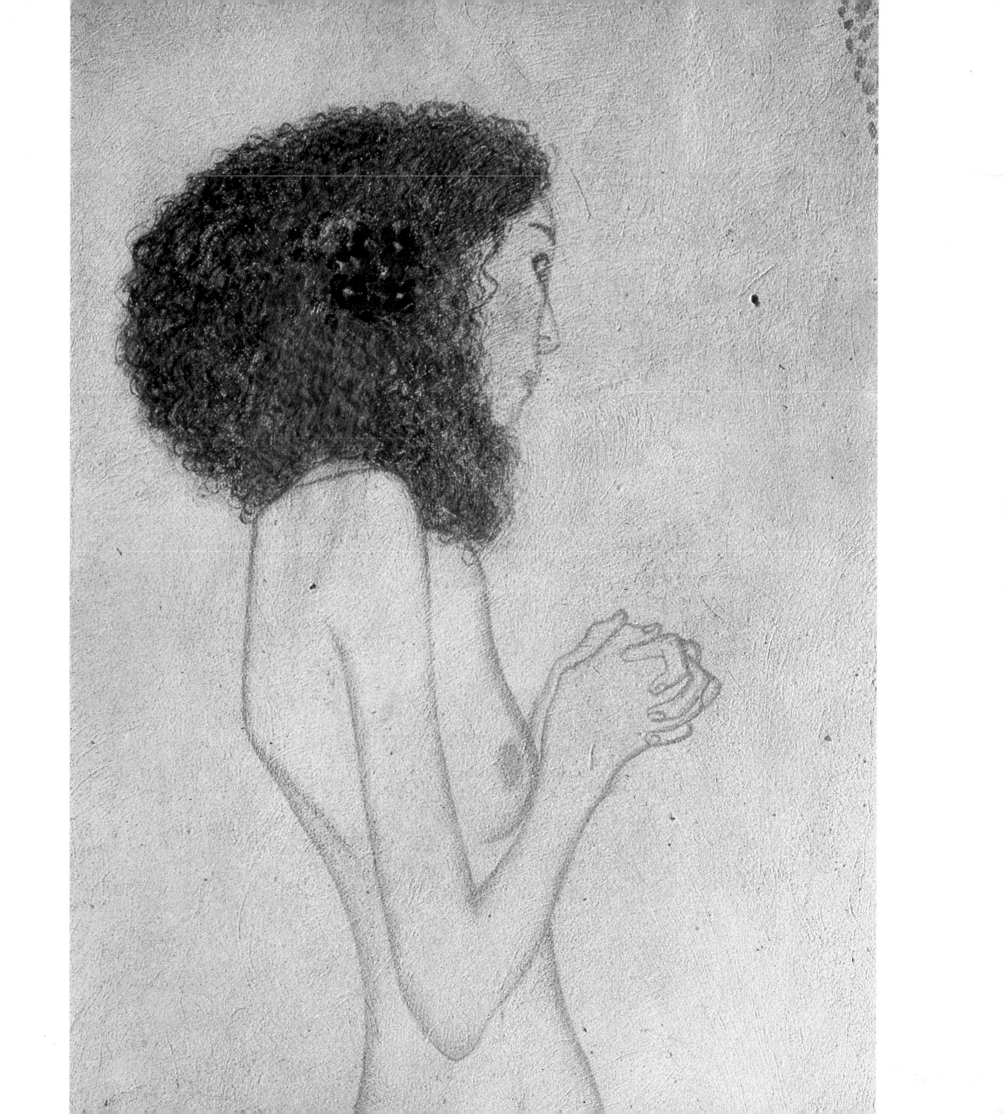

PLATE 20

'The Well-armed Strong One, Compassion and Ambition'
Beethoven frieze, 1901–2
Casein on stucco
Österreichische Galerie, Vienna

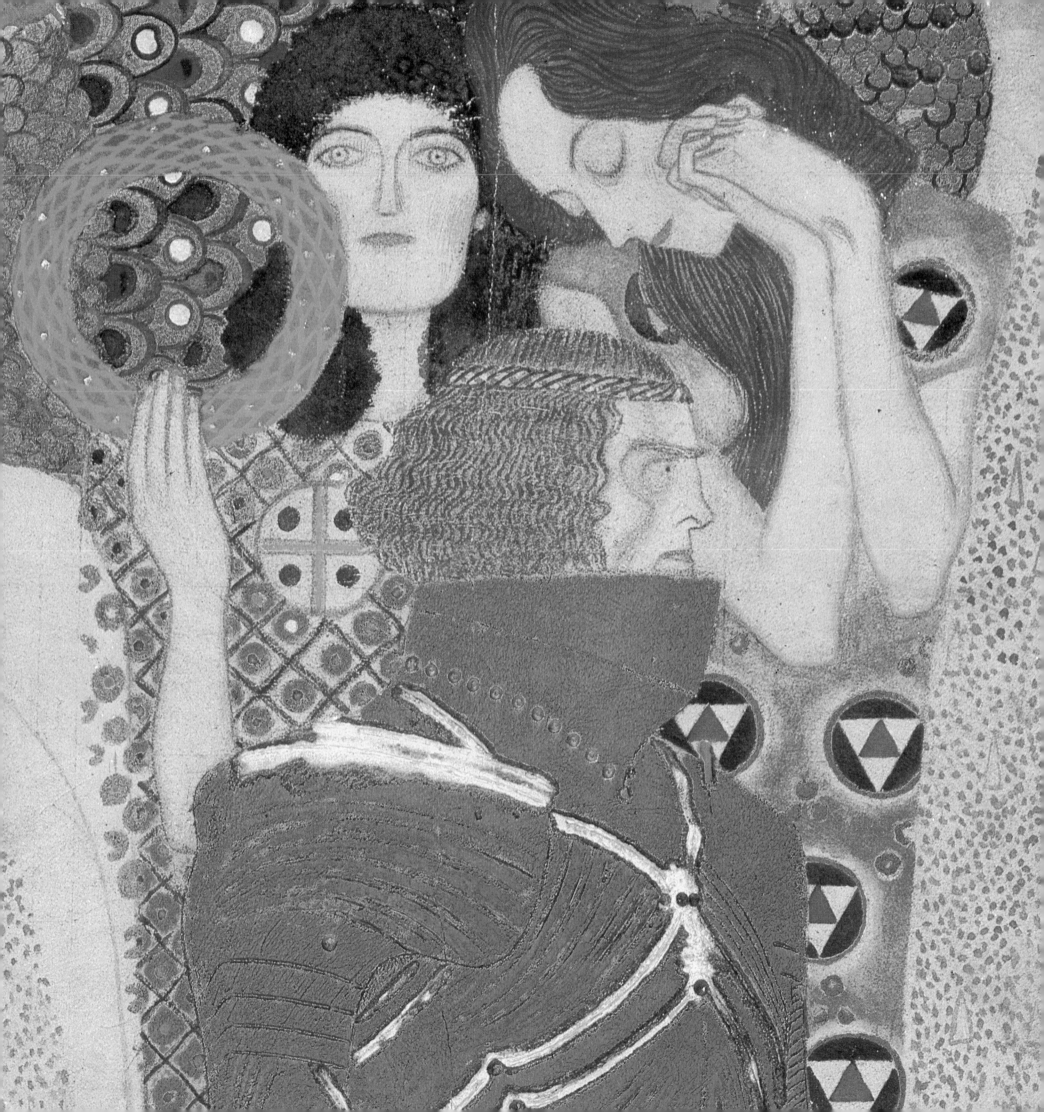

PLATE 21

'Debauchery, Unchastity, Excess' from **'The Hostile Powers'**
Beethoven frieze, 1901–2
Casein on stucco
Österreichische Galerie, Vienna

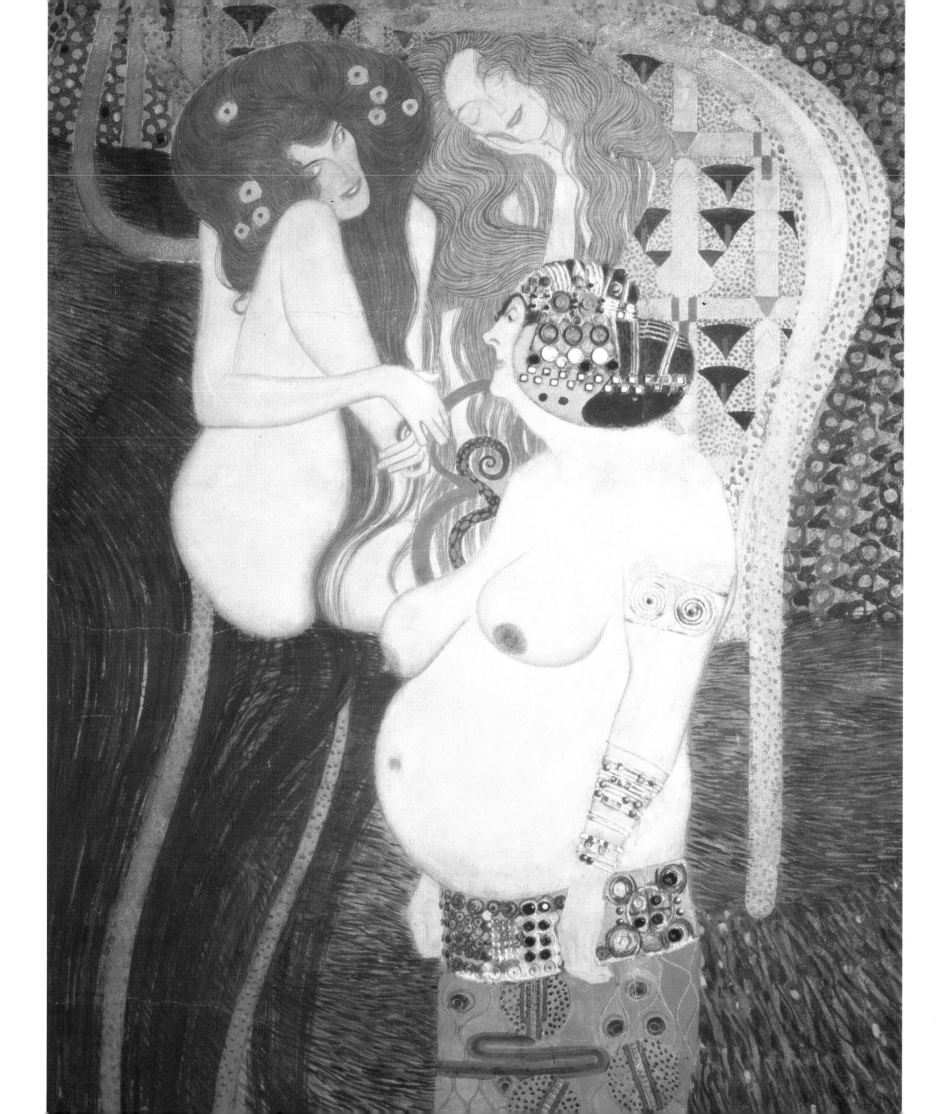

PLATE 22

'Corroding Grief' from **'The Hostile Powers'**
Beethoven frieze, 1901–2
Casein on stucco
Österreichische Galerie, Vienna

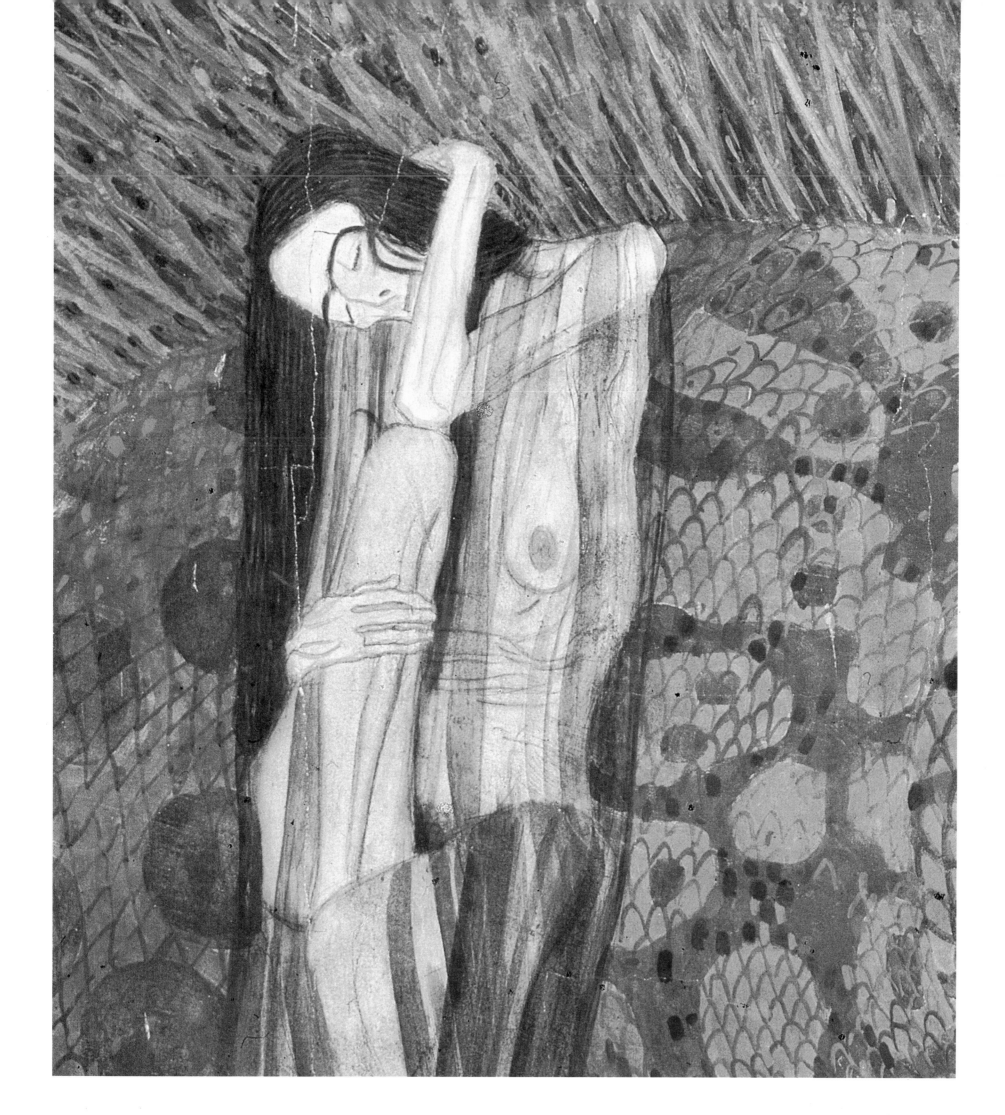

PLATE 23

'Poetry' from the Beethoven frieze, 1901–2
Casein on stucco
Österreichische Galerie, Vienna

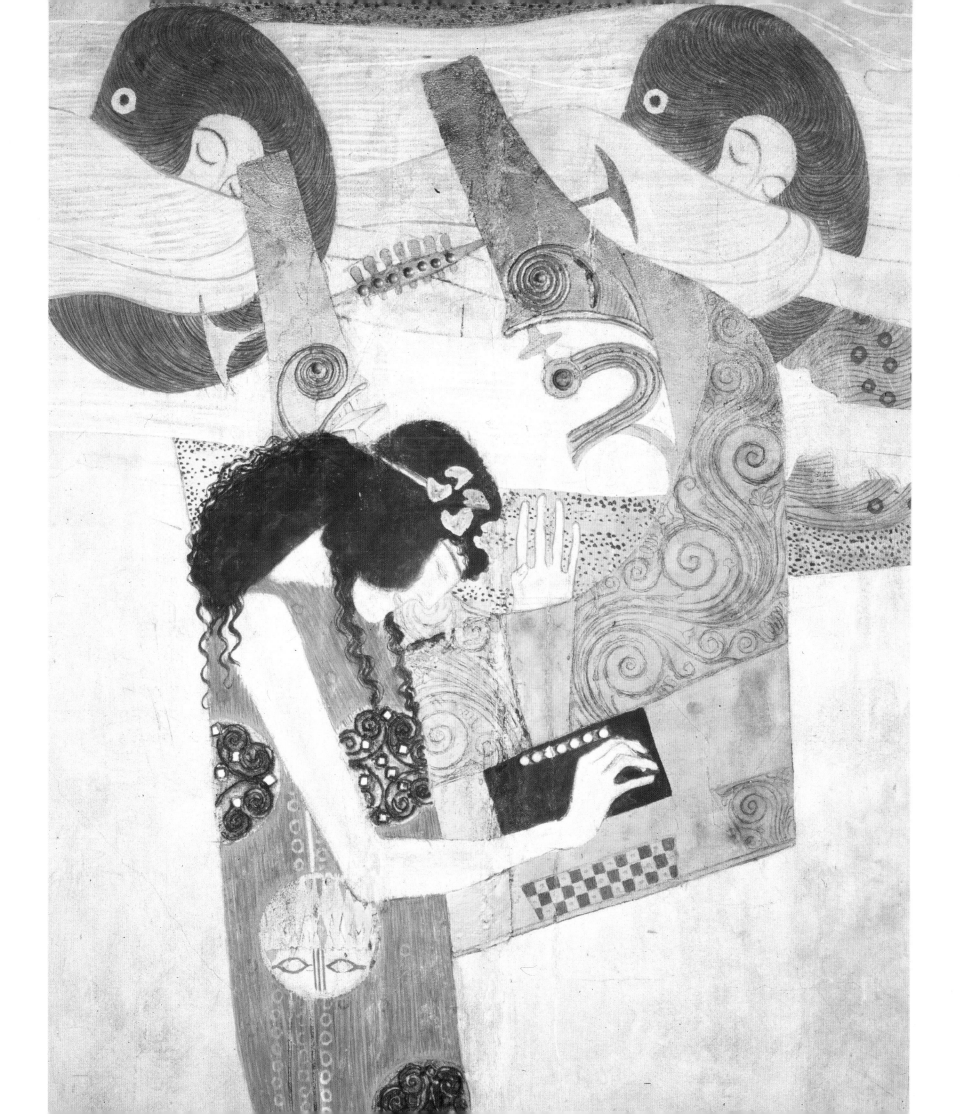

PLATE 24

'**The Arts**' from the Beethoven frieze, 1901–2
Casein on stucco
Österreichische Galerie, Vienna

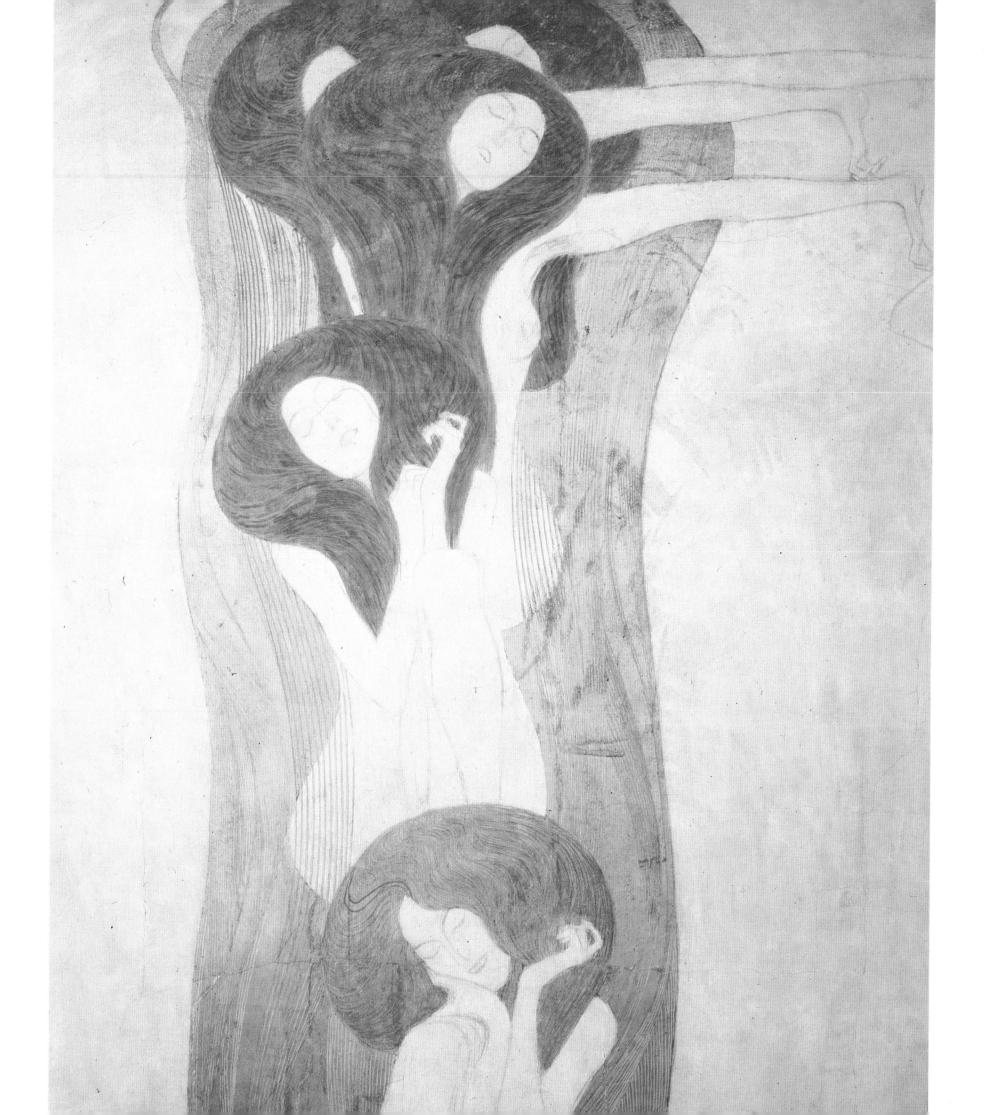

PLATE 25

'Here's a kiss to the whole world!' from **'Praise to Joy, the
God-descended'**
Beethoven frieze, 1901–2
Casein on stucco
Österreichische Galerie, Vienna

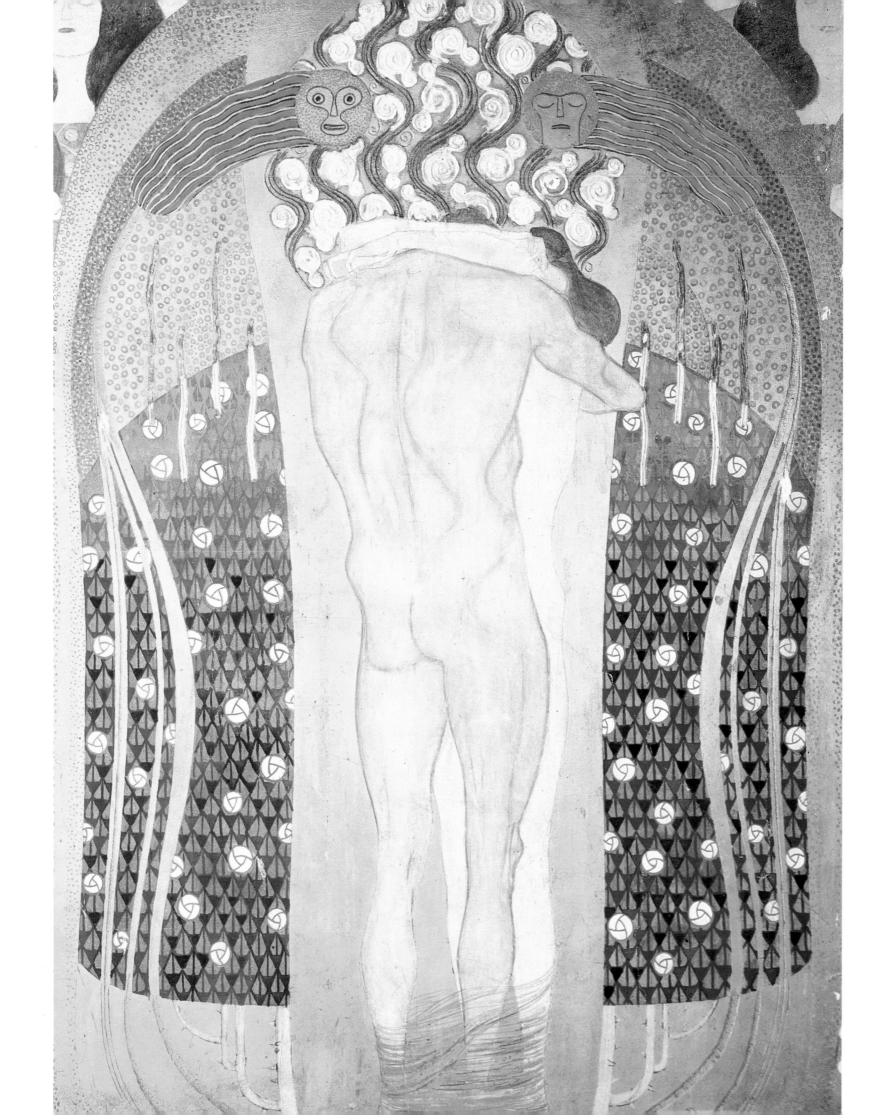

PLATE 26

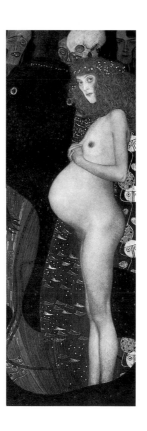

Hope I, 1903
Oil on canvas, 181 × 67 cm
National Gallery, Ottawa

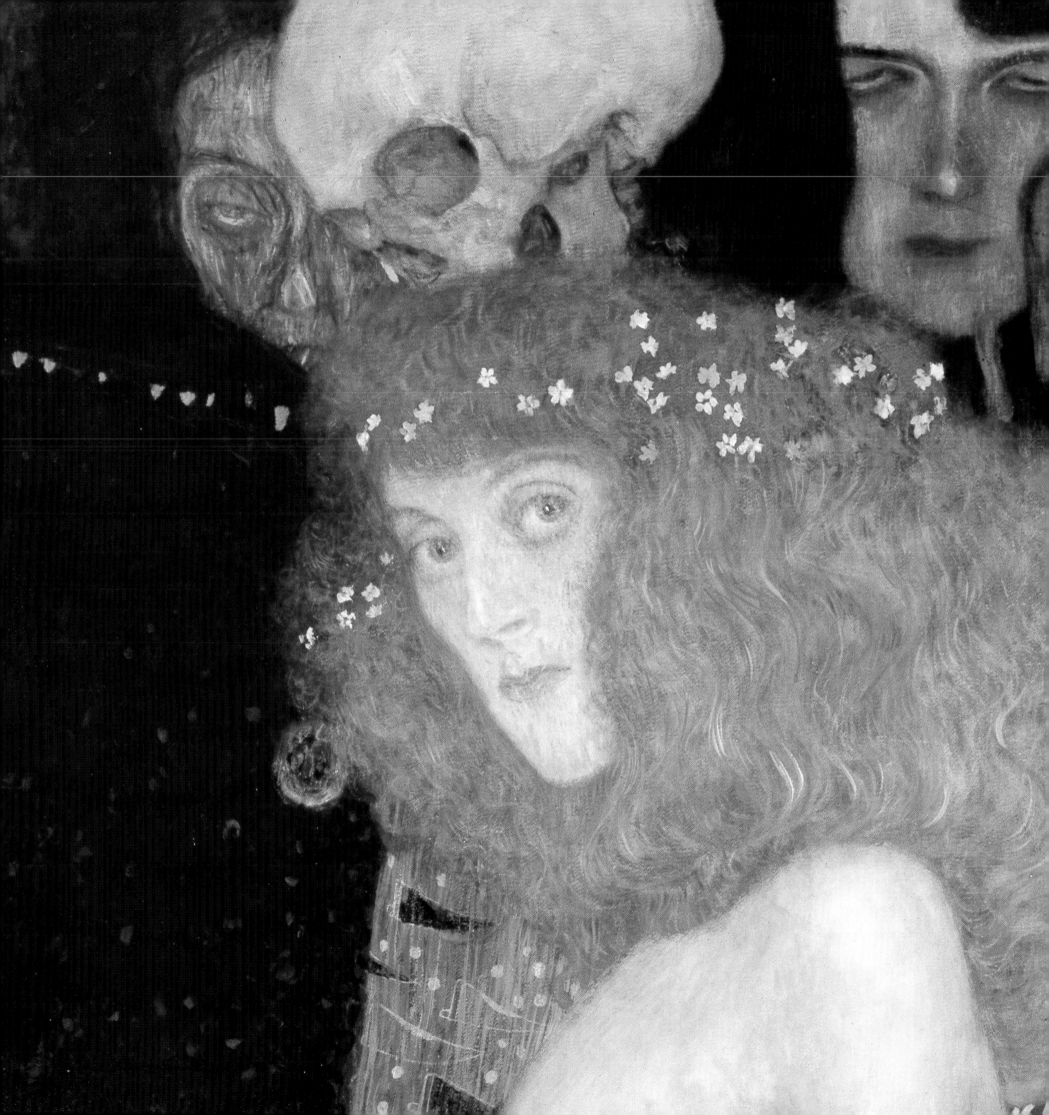

PLATE 27

Hermine Gallia, 1903–4
Oil on canvas, 170 × 96 cm
Inscribed t.r.: GUSTAV KLIMT 1904
National Gallery, London

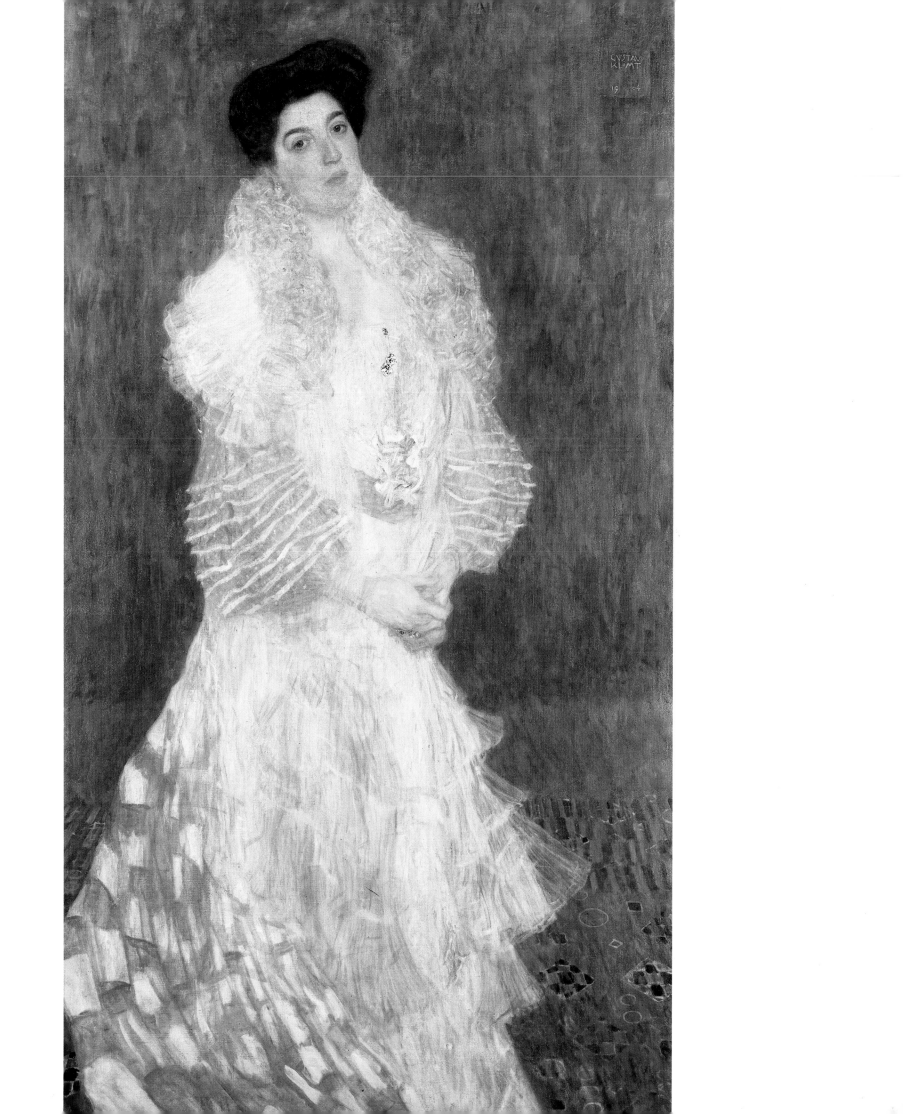

PLATE 28

Water Snakes I (Friends), 1904–7
Mixed technique on parchment, 50 × 20 cm
Inscribed b.r.: GUSTAV KLIMT
Österreichische Galerie, Vienna

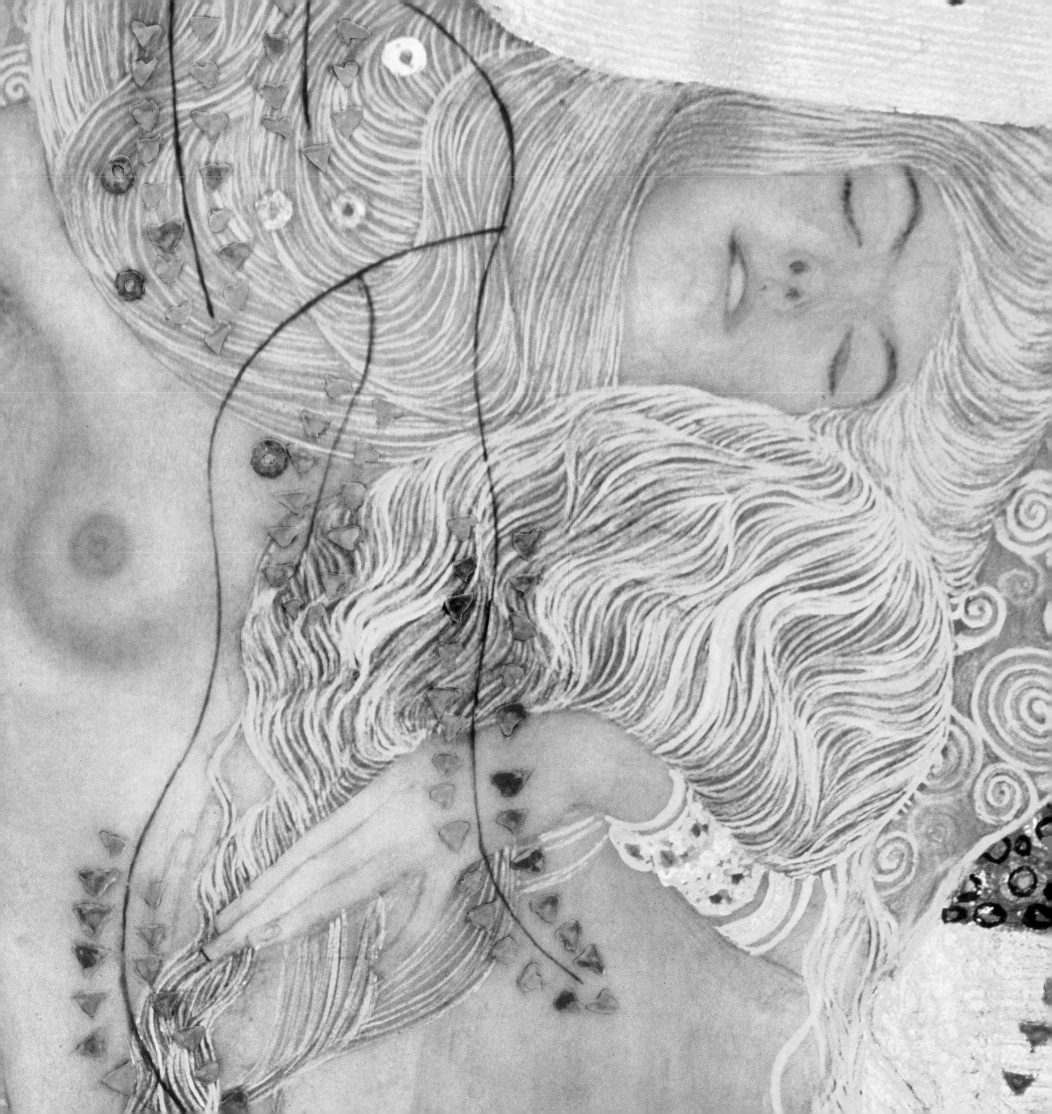

PLATE 29

Water Snakes II (Friends), 1904–7
Oil on canvas, 80 × 145 cm
Inscribed b.r.: GUSTAV KLIMT
Privately owned

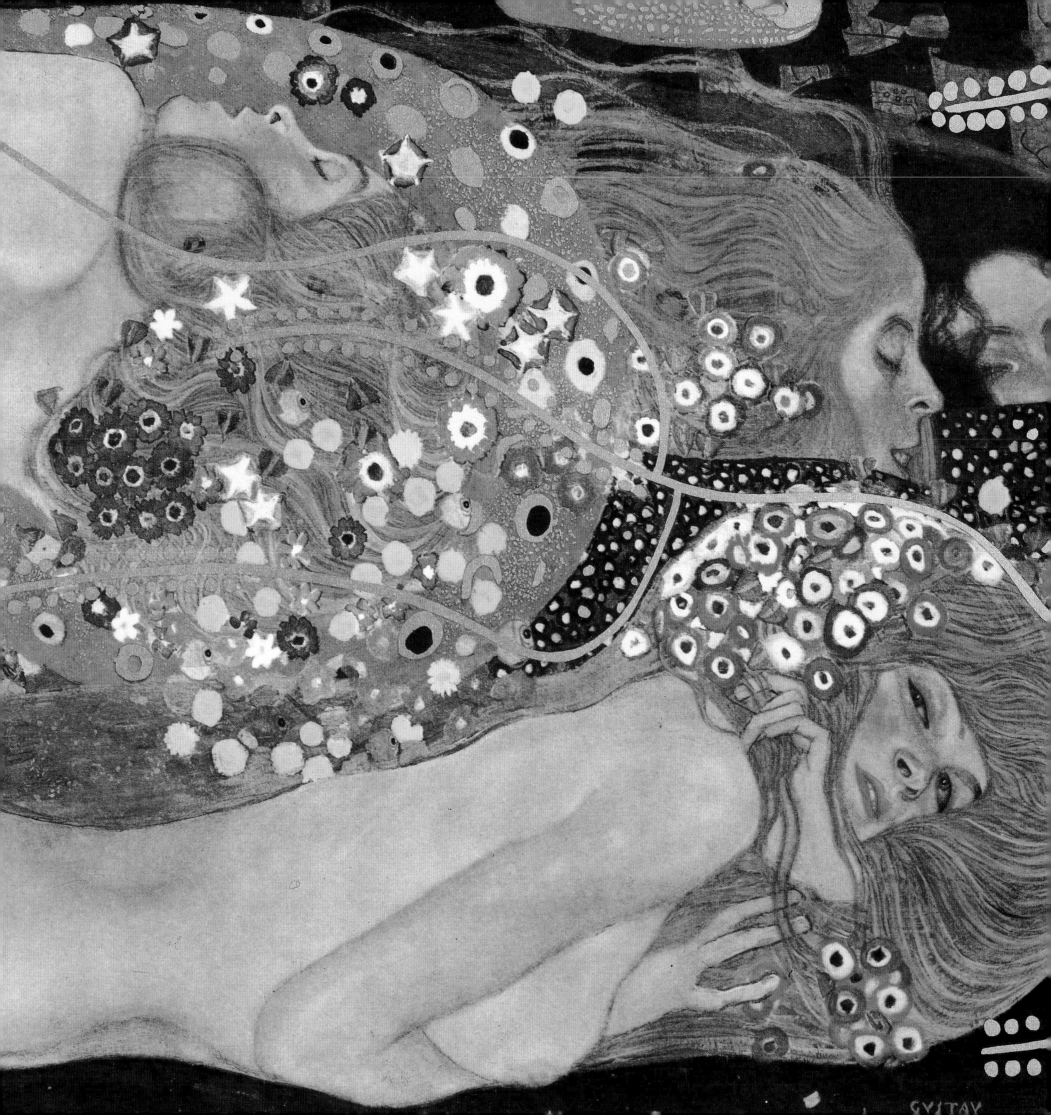

PLATE 30

The Three Ages of Woman, 1905
Oil on canvas, 180 × 180 cm
Galleria Nazionale d'Arte Moderna, Rome

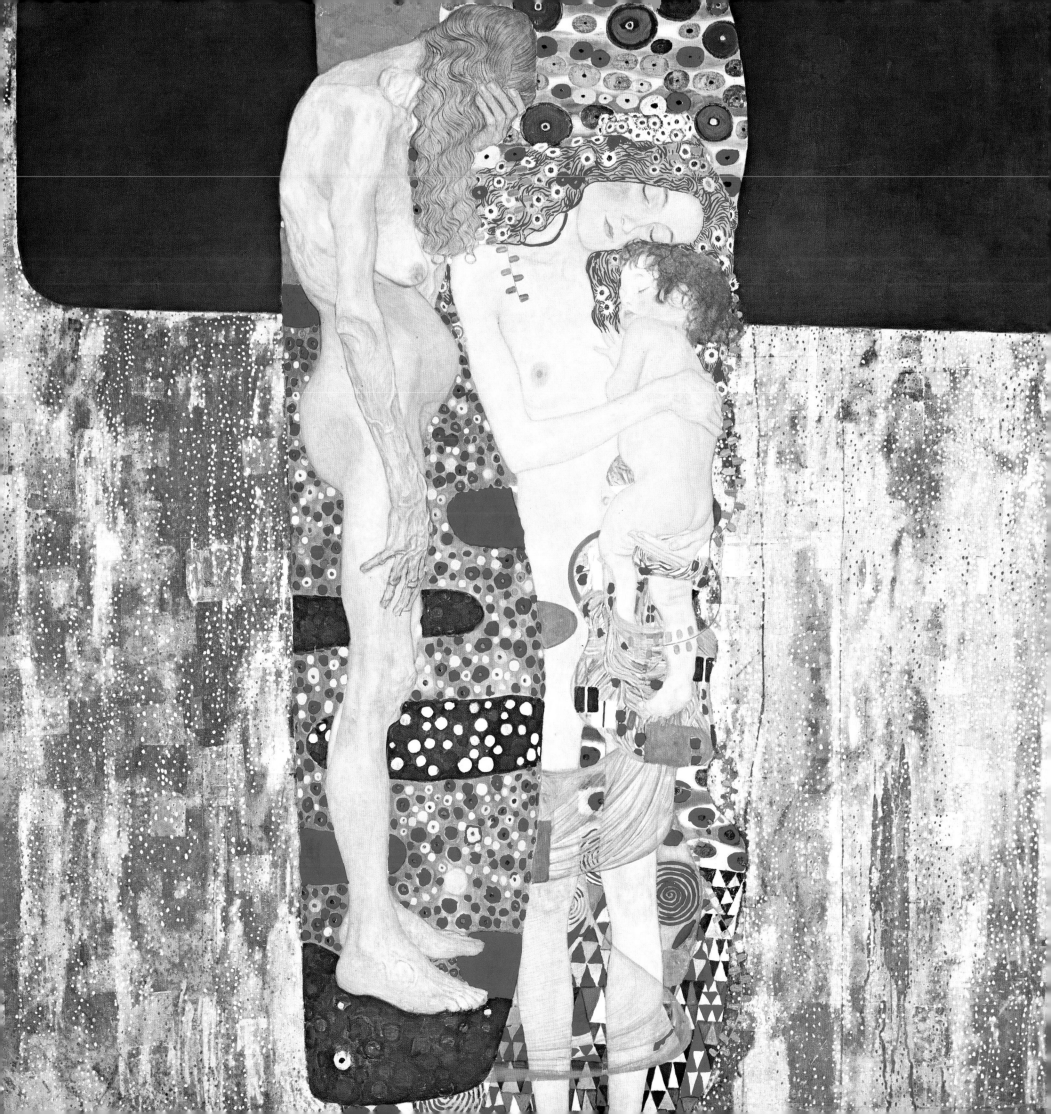

PLATE 31

Margaret Stonborough-Wittgenstein, 1905
Oil on canvas, 180 × 90 cm
Inscribed b.l.: GUSTAV KLIMT 1905
Bayerische Staatsgemäldesammlungen (Neue Pinakothek), Munich

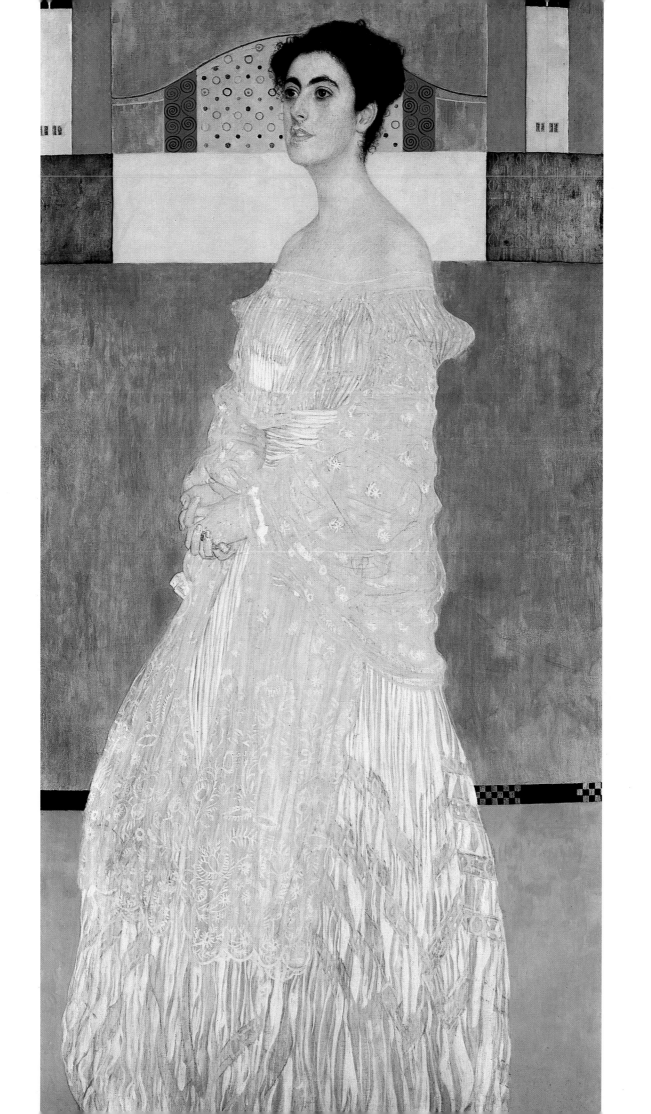

PLATE 32

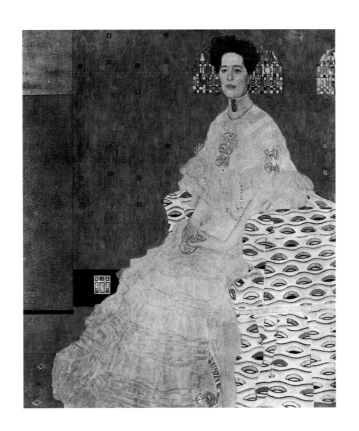

Fritza, Riedler, 1906
Oil on canvas, 153 × 133 cm
Inscribed b.l.: GUSTAV KLIMT 1906
Österreichische Galerie, Vienna

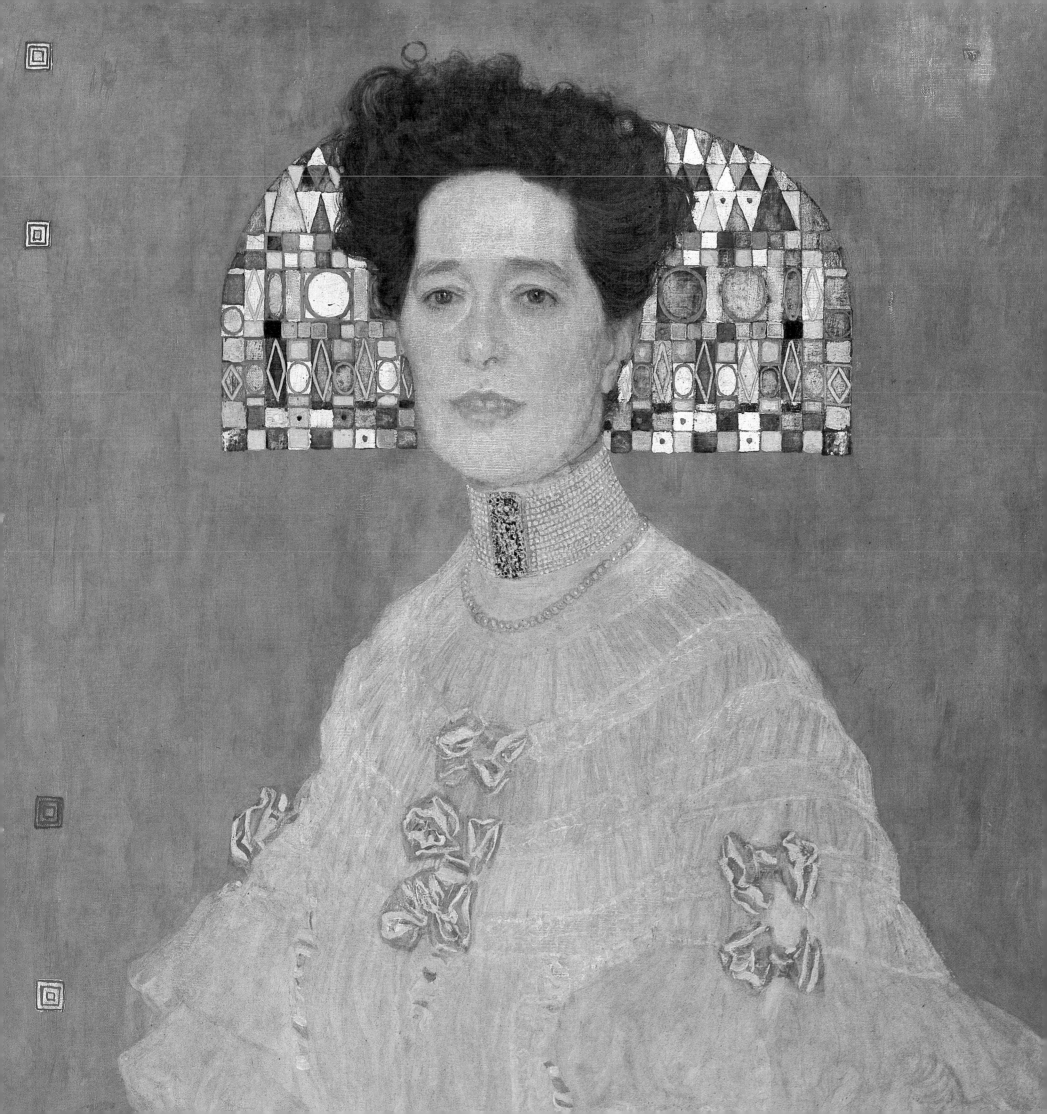

PLATE 33

Adele Bloch-Bauer I, 1907
Oil on canvas, 138 × 138 cm
Inscribed b.r.: GUSTAV KLIMT 1907
Österreichische Galerie, Vienna

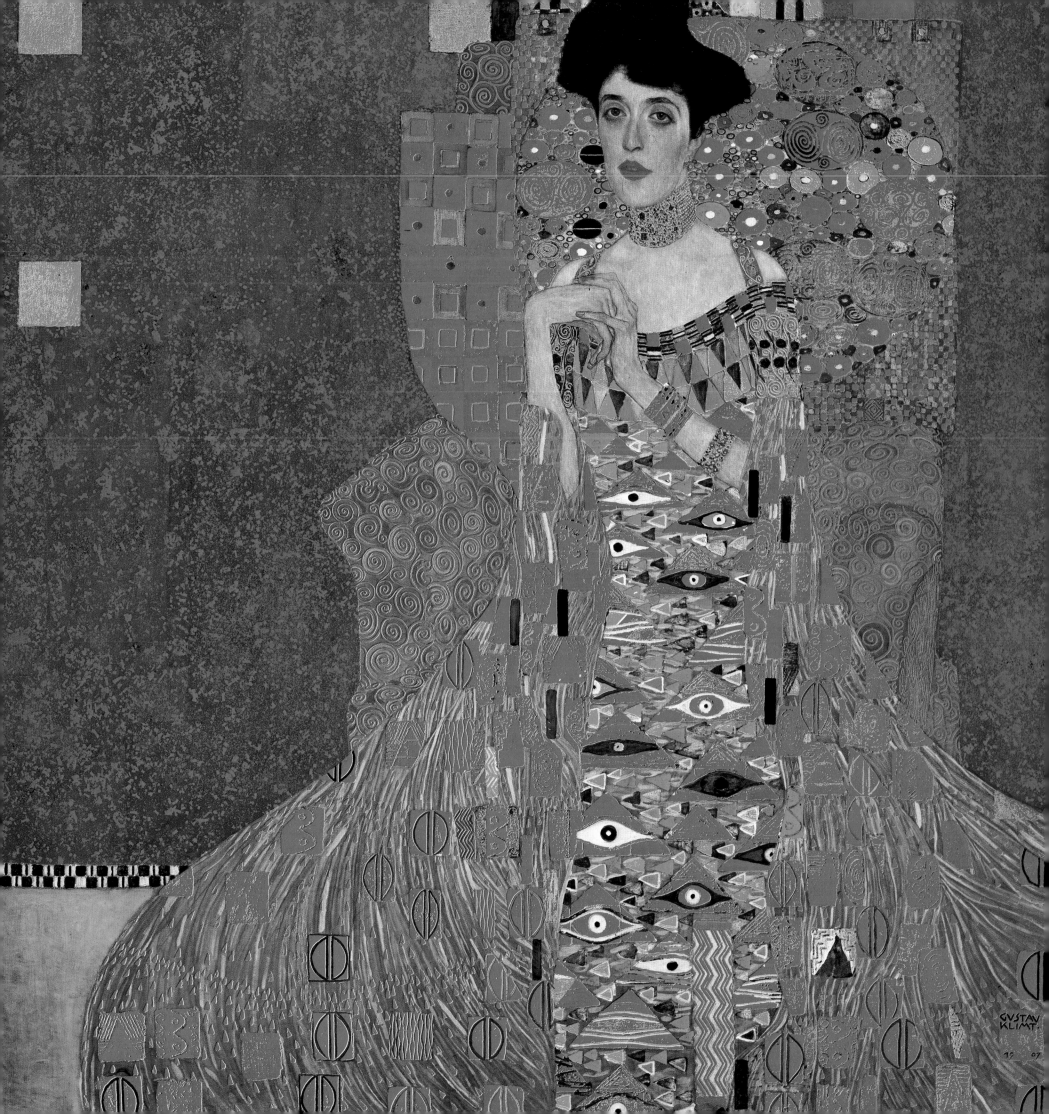

PLATE 34

Danae, 1907–8
Oil on canvas, 77 × 83 cm
Inscribed b.r.: GUSTAV KLIMT
Privately owned

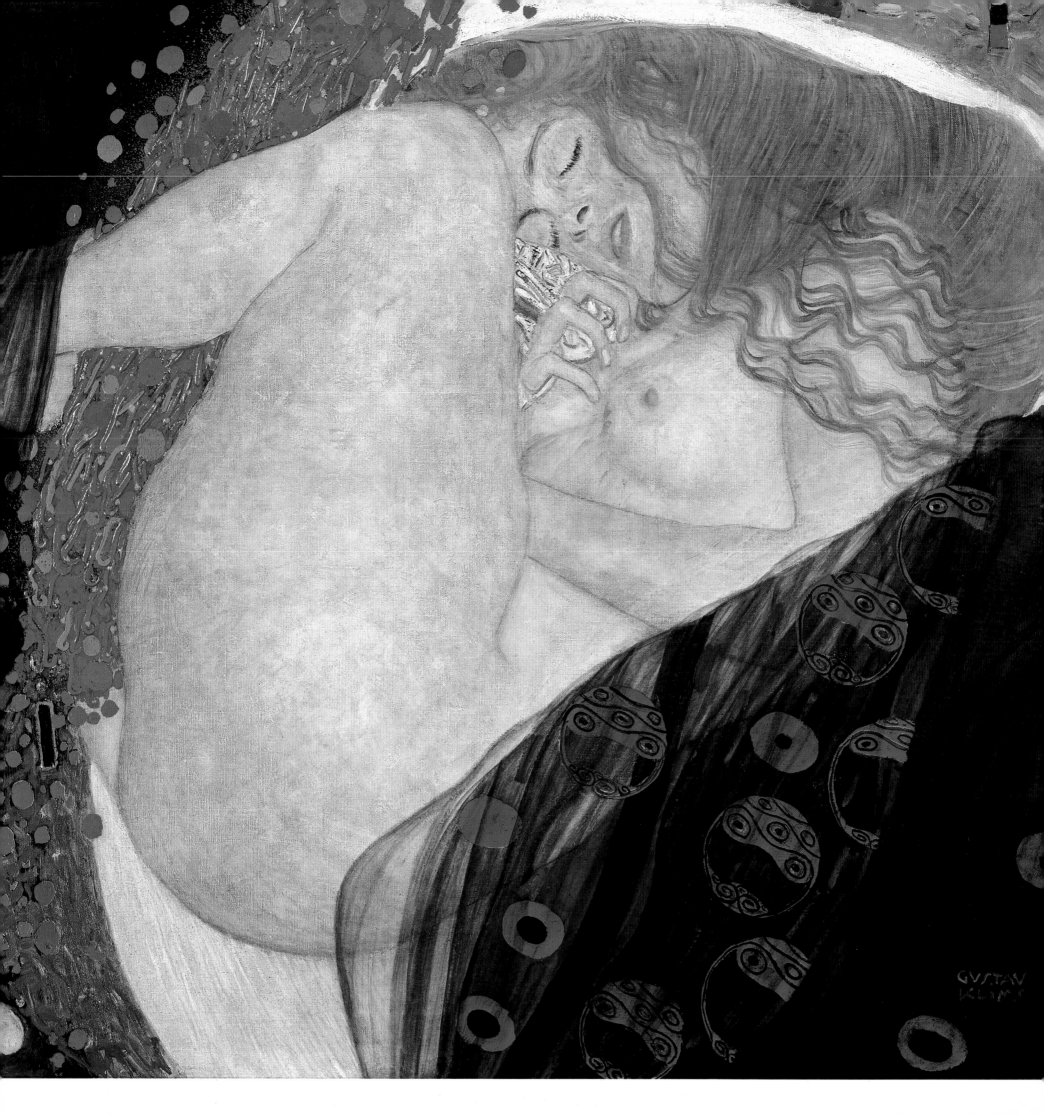

PLATE 35

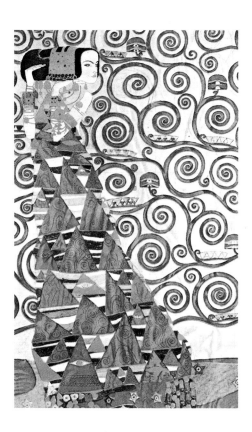

Expectancy (Cartoon for the Stoclet frieze), 1905–9
Mixed technique on paper
Österreichisches Museum für Angewandte Kunst, Vienna

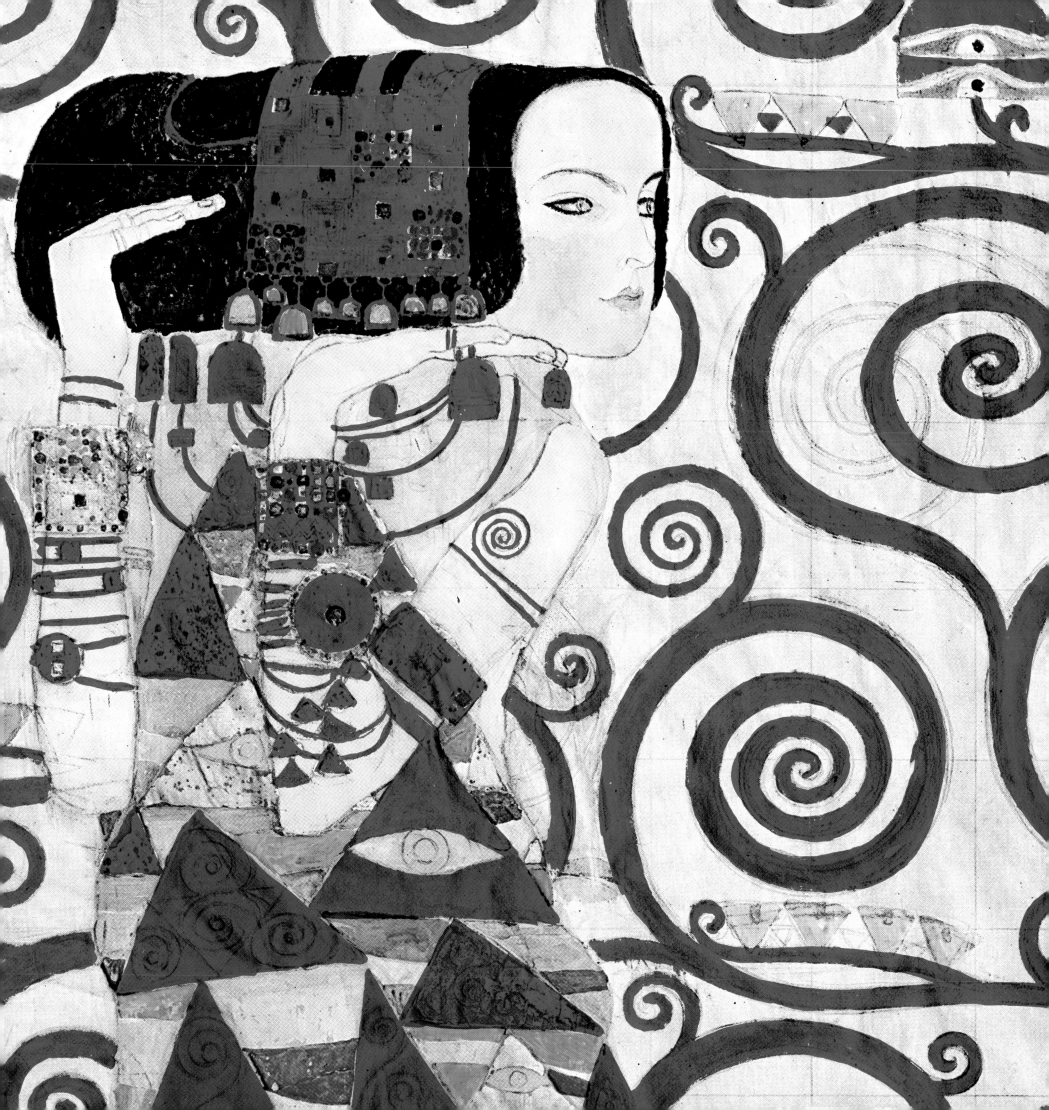

PLATE 36

Fulfilment (Cartoon for the Stoclet frieze), 1905–9
Mixed technique on paper
Österreichisches Museum für Angewandte Kunst, Vienna

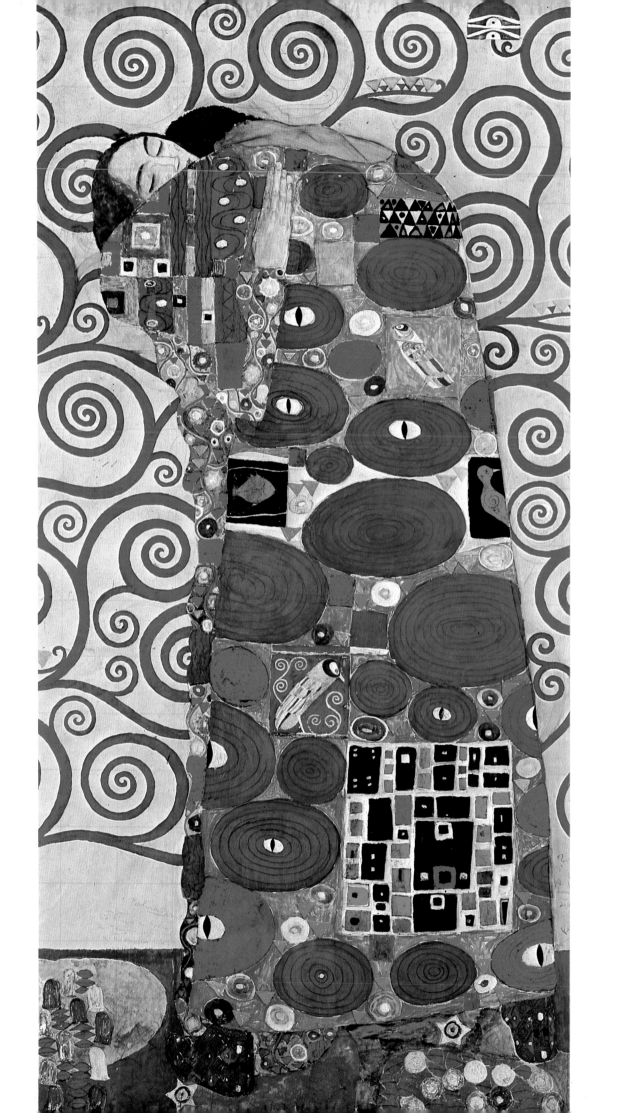

PLATE 37

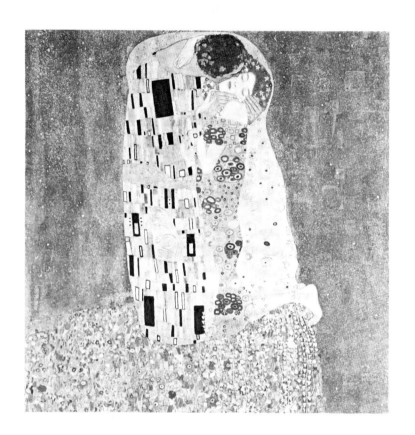

The Kiss, 1907–8
Oil on canvas, 180 × 180 cm
Inscribed b.r.: GUSTAV KLIMT
Österreichische Galerie, Vienna

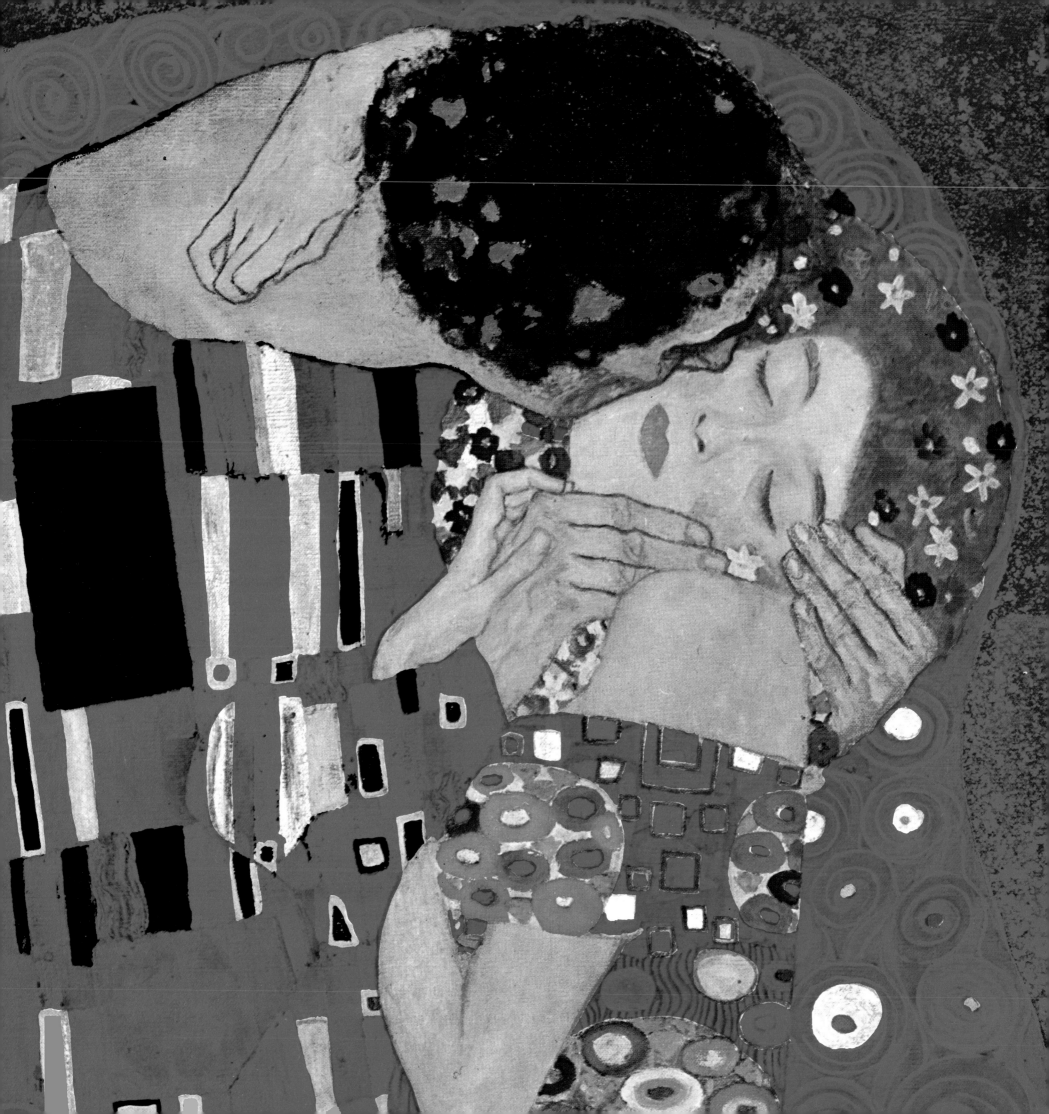

PLATE 38

Hope II, 1907–8
Oil on canvas, 110 × 110 cm
Museum of Modern Art, New York

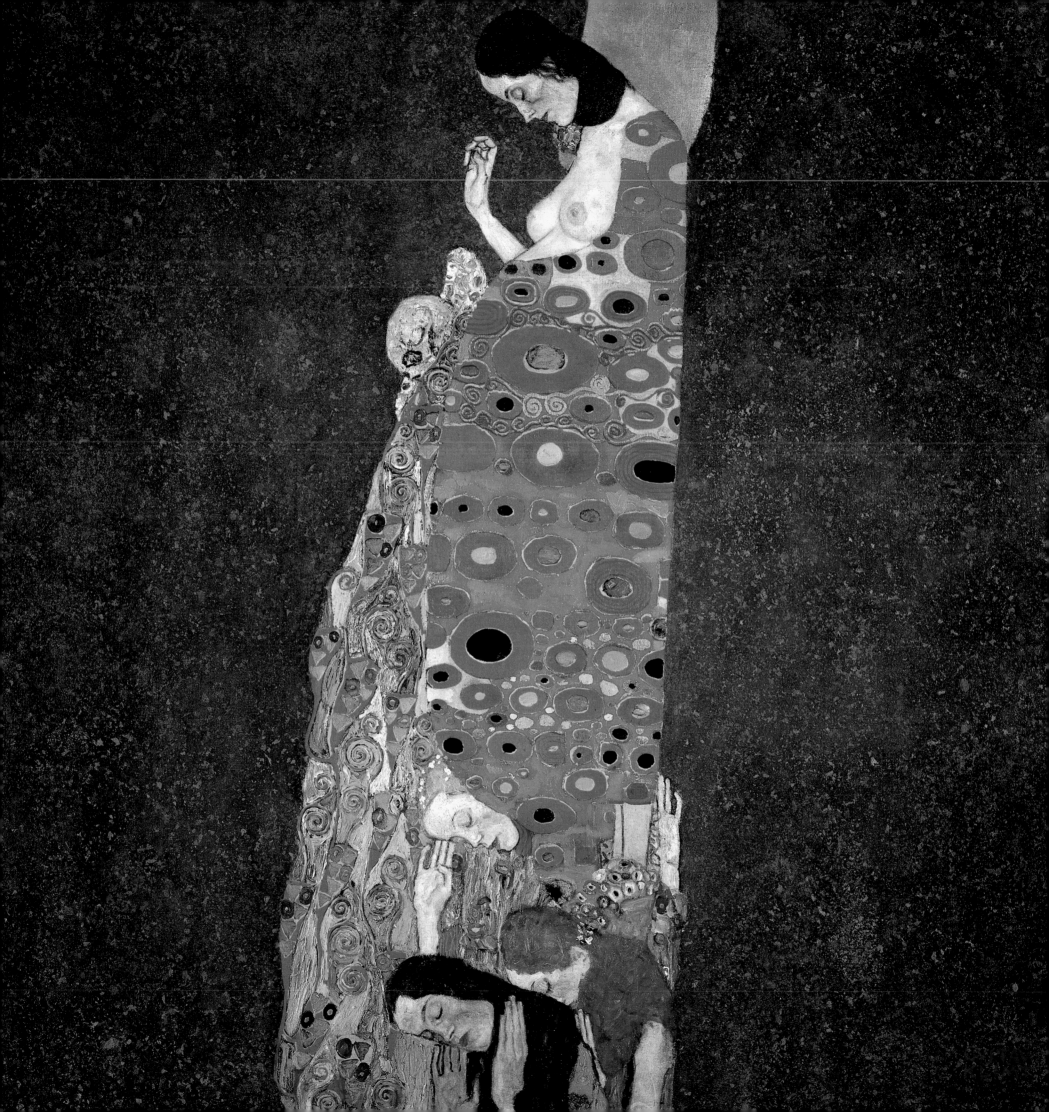

PLATE 39

Mother with Children, 1909–10
Oil on canvas, 90 × 90 cm
Inscribed b.r.: GUSTAV KLIMT
Privately owned

PLATE 40

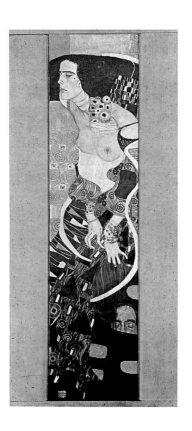

Judith II (Salome), 1909
Oil on canvas, 178 × 46 cm
Inscribed b.l.: GUSTAV KLIMT 1909
Galleria d'Arte Moderna, Venice

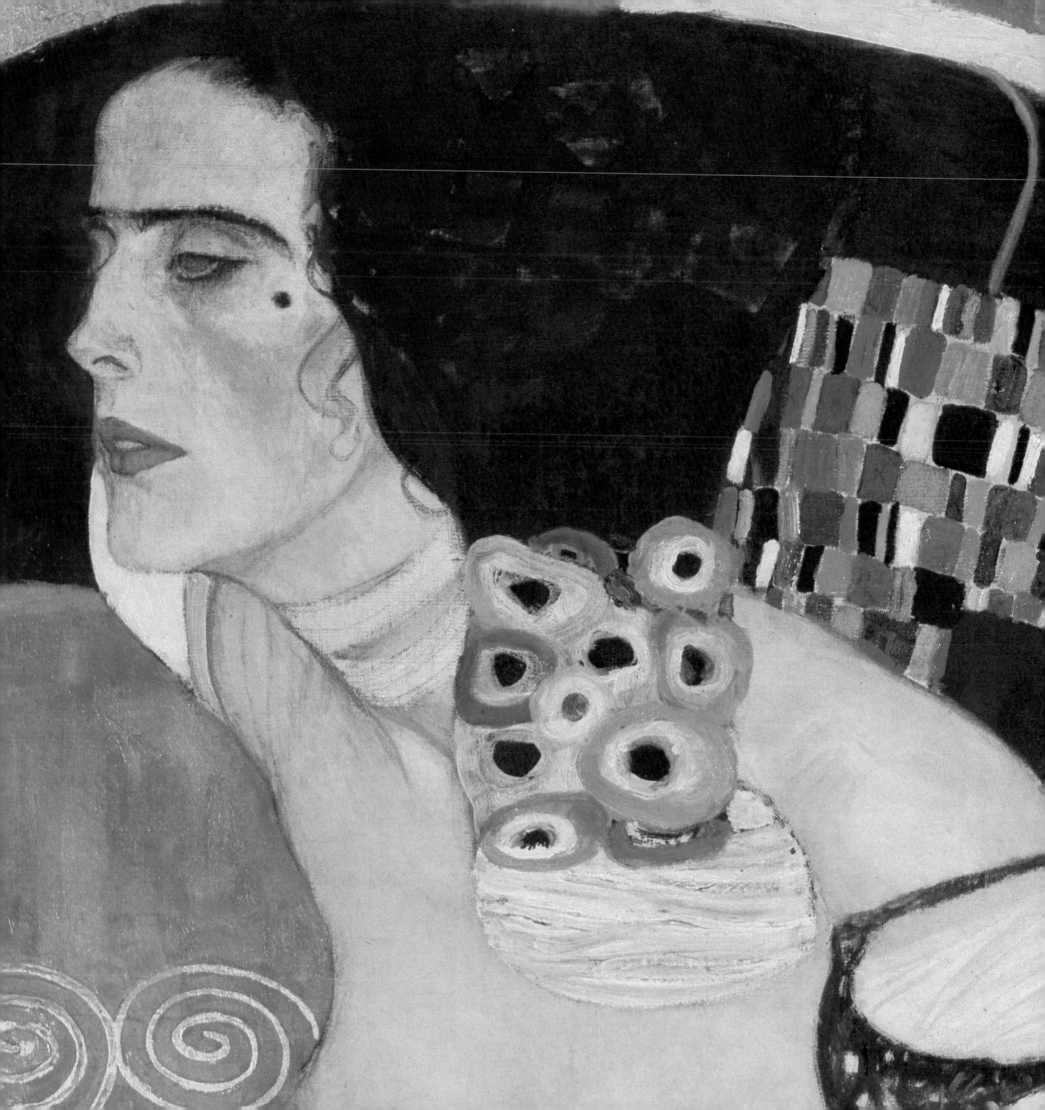

PLATE 41

The Black Feathered Hat, 1910
Oil on canvas, 79 × 63 cm
Inscribed b.r.: GUSTAV KLIMT 1910
Privately owned

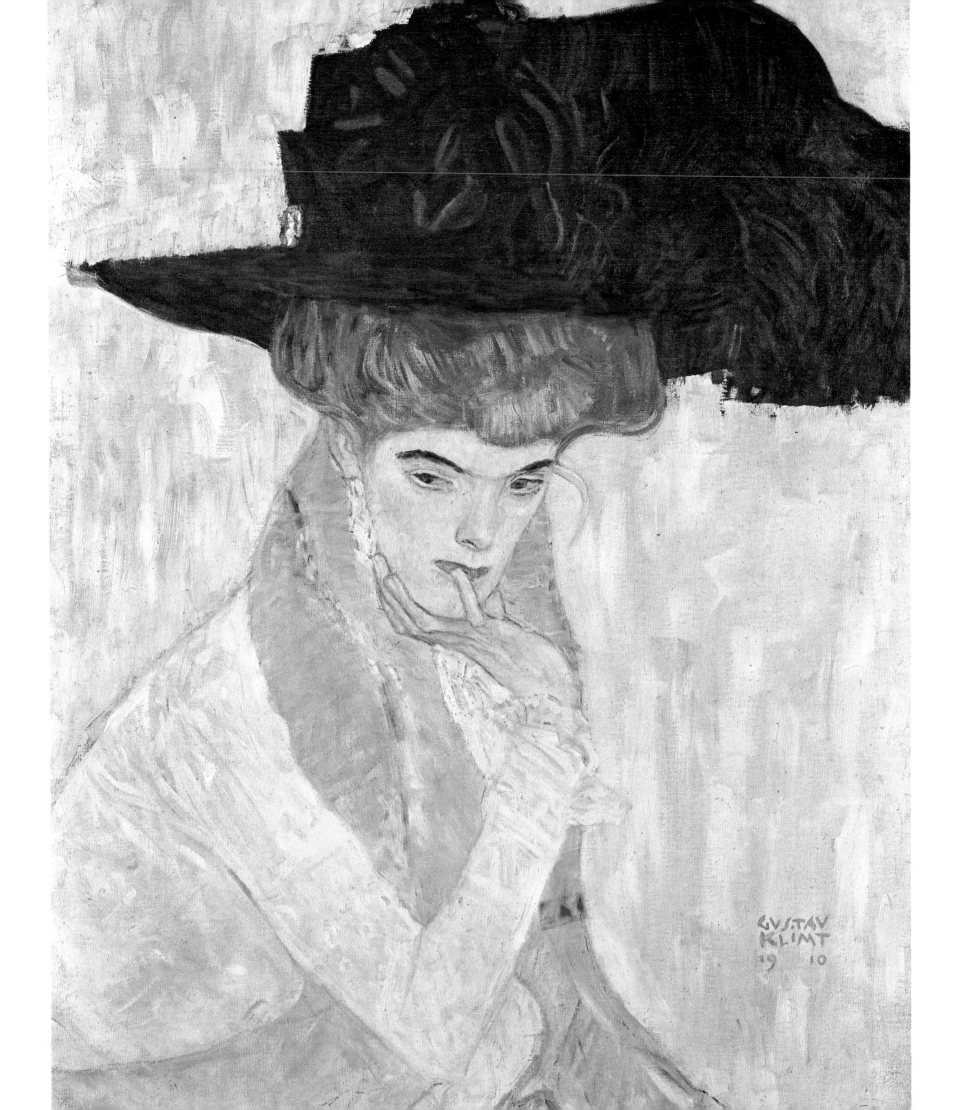

PLATE 42

Lady With Hat and Feather Boa, 1909
Oil on canvas, 69 × 55 cm
Inscribed c.l.: GUSTAV KLIMT
Österreichische Galerie, Vienna

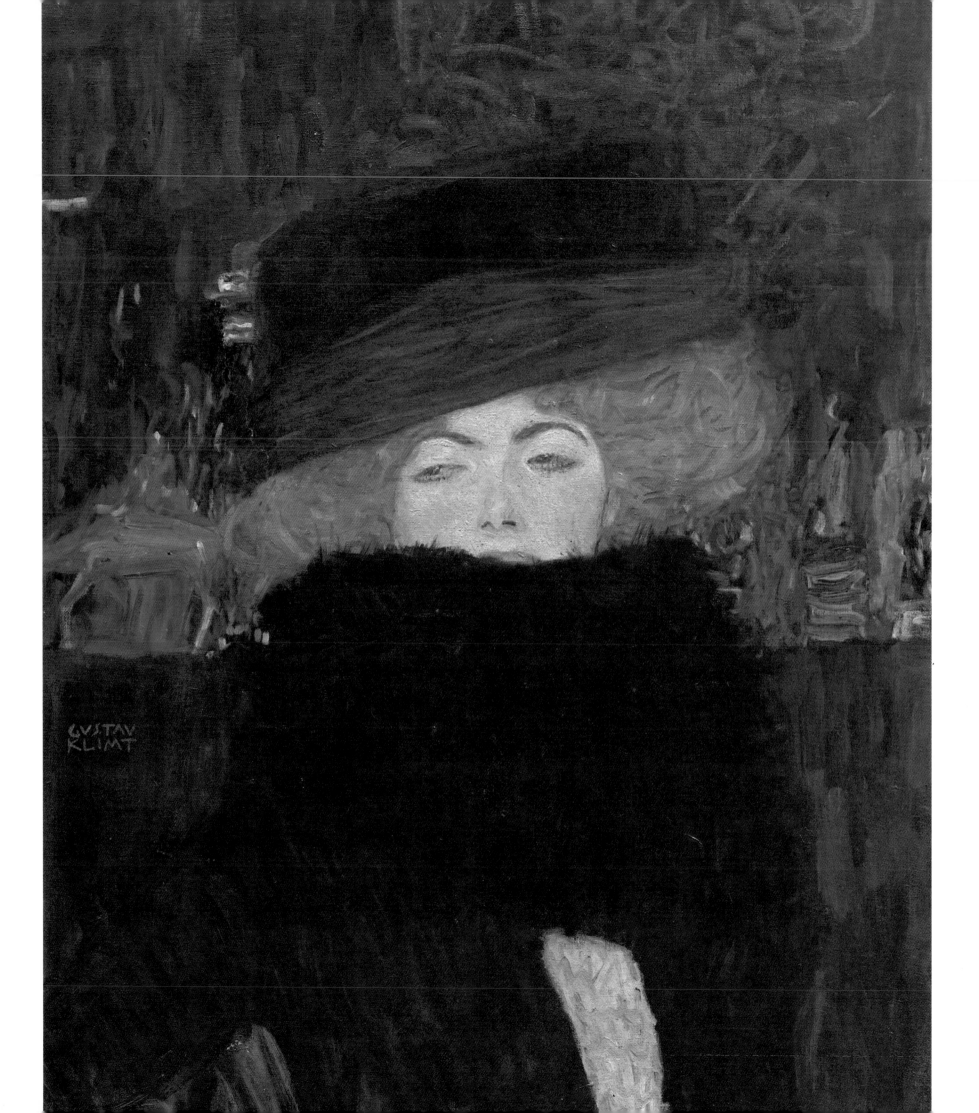

PLATE 43

Adele Bloch-Bauer II, 1912
Oil on canvas, 190 × 120 cm
Inscribed b.r.: GUSTAV KLIMT
Österreichische Galerie, Vienna, on loan to the Museum Moderner Kunst

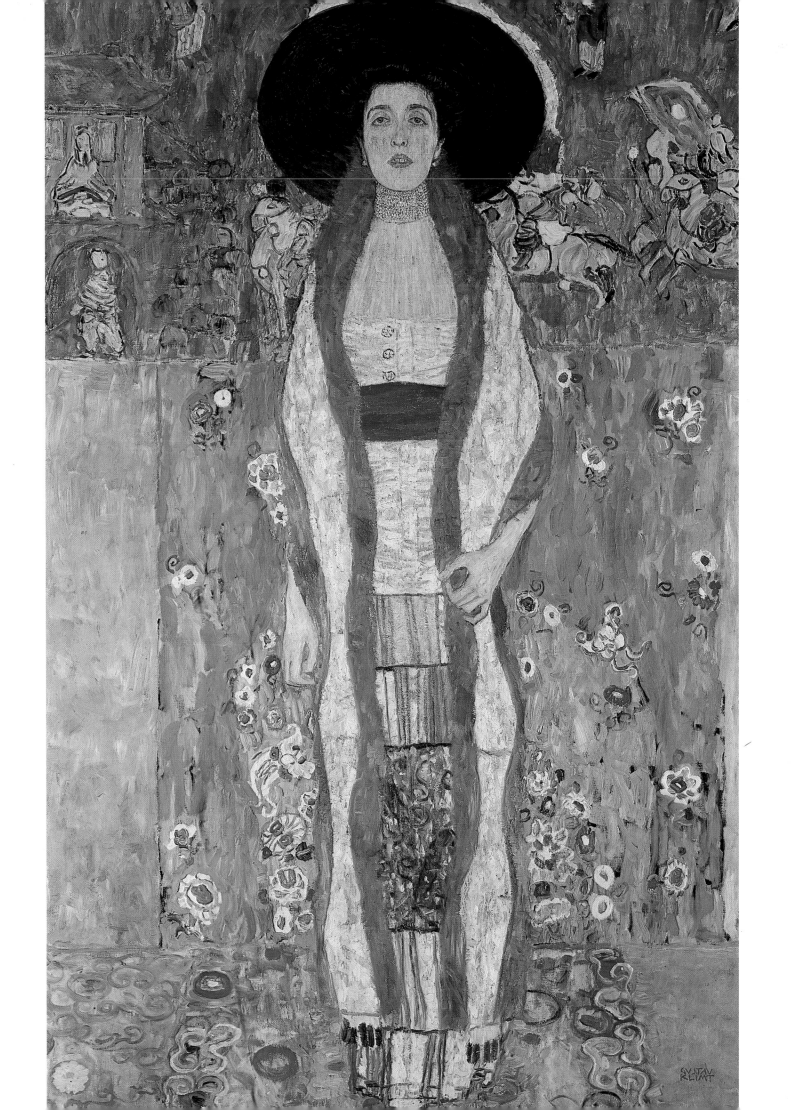

PLATE 44

Mäda Primavesi, *c.* 1912
Oil on canvas, 150 × 110 cm
Inscribed b.r.: GUSTAV KLIMT
Privately owned

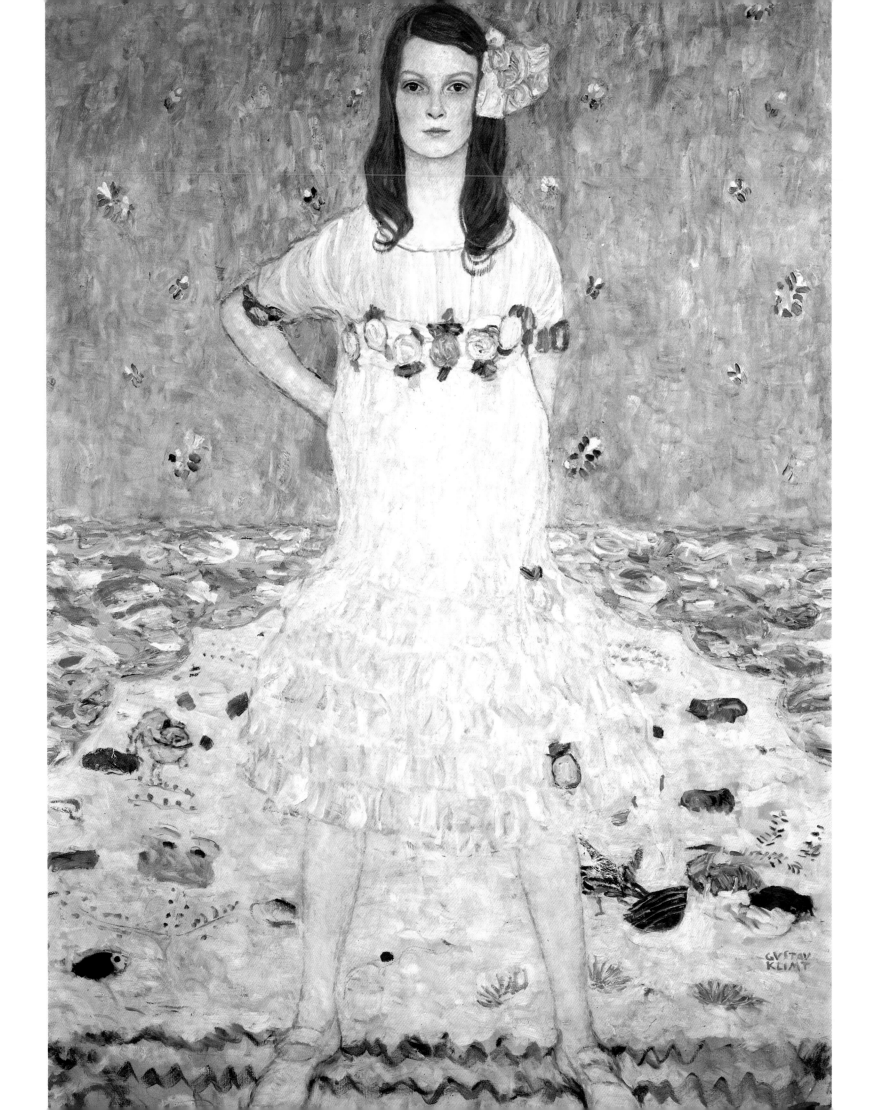

PLATE 45

Death and Life, 1911–16
Oil on canvas, 178 × 198 cm
Inscribed b.r.: GUSTAV KLIMT
Privately owned

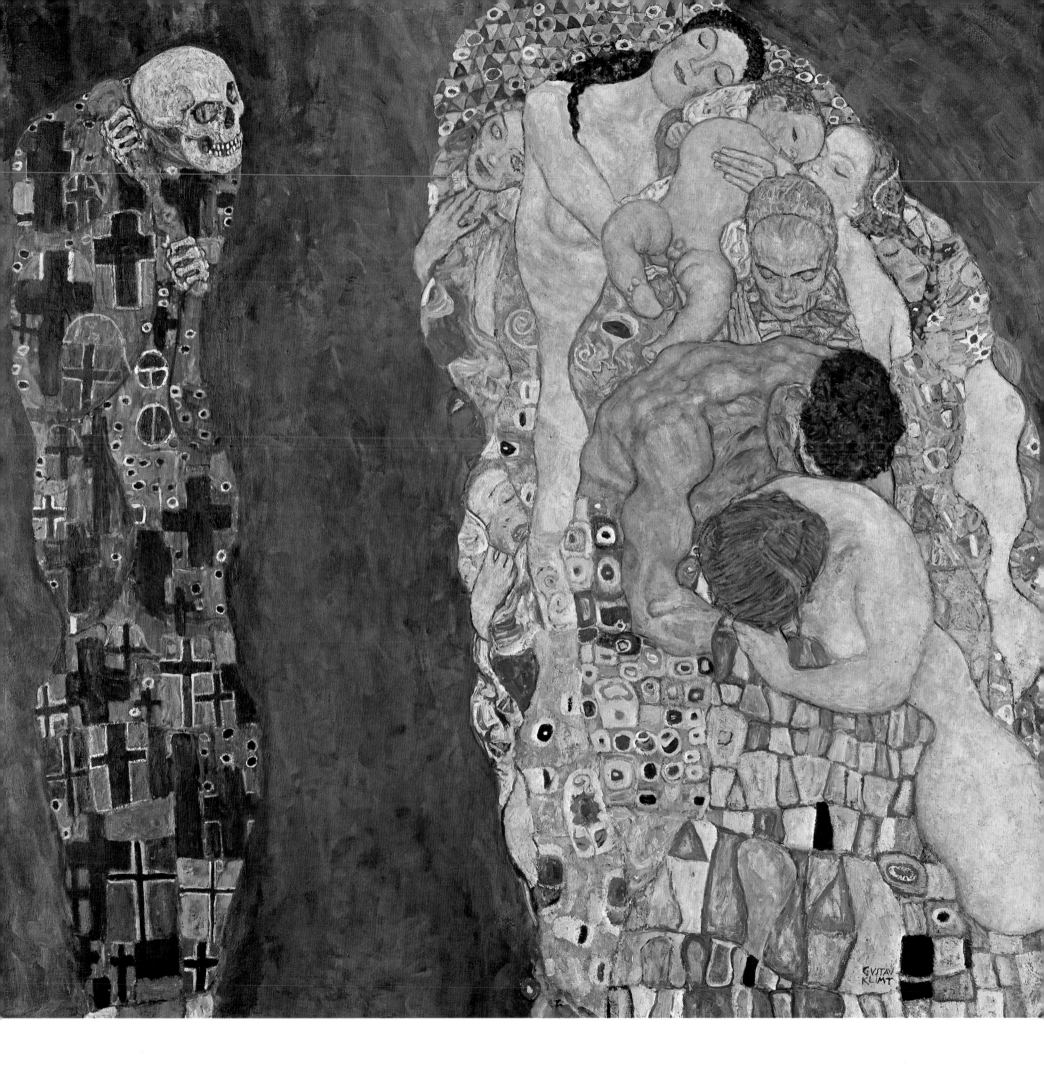

PLATE 46

Virgin, 1913
Oil on canvas, 190 × 200 cm
Inscribed b.r.: GUSTAV KLIMT
Narodní Galerie, Prague

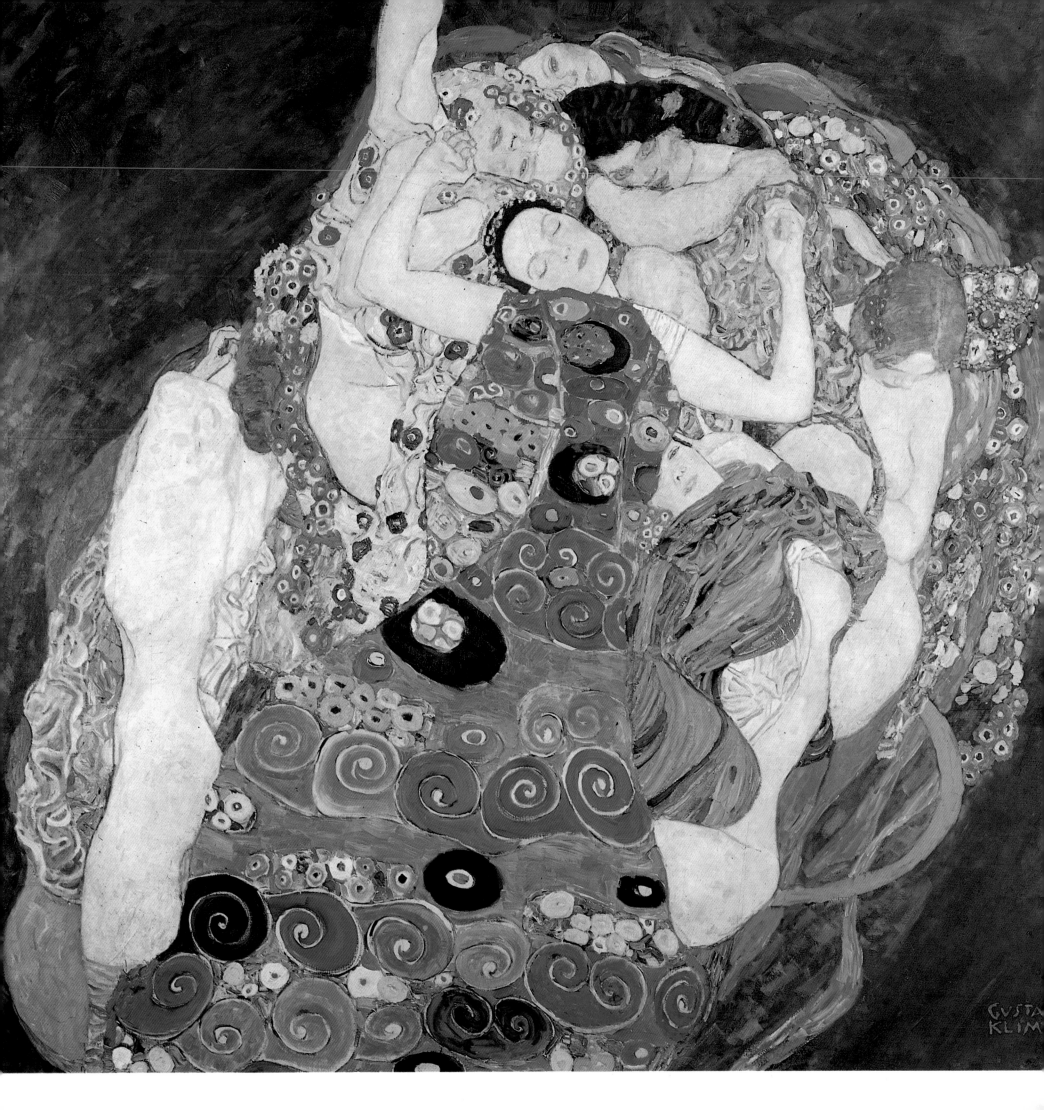

PLATE 47

Elisabeth Bachofen-Echt, *c.* 1914
Oil on canvas, 180 × 128 cm
Inscribed r.: GUSTAV KLIMT
Lederer Collection, Geneva

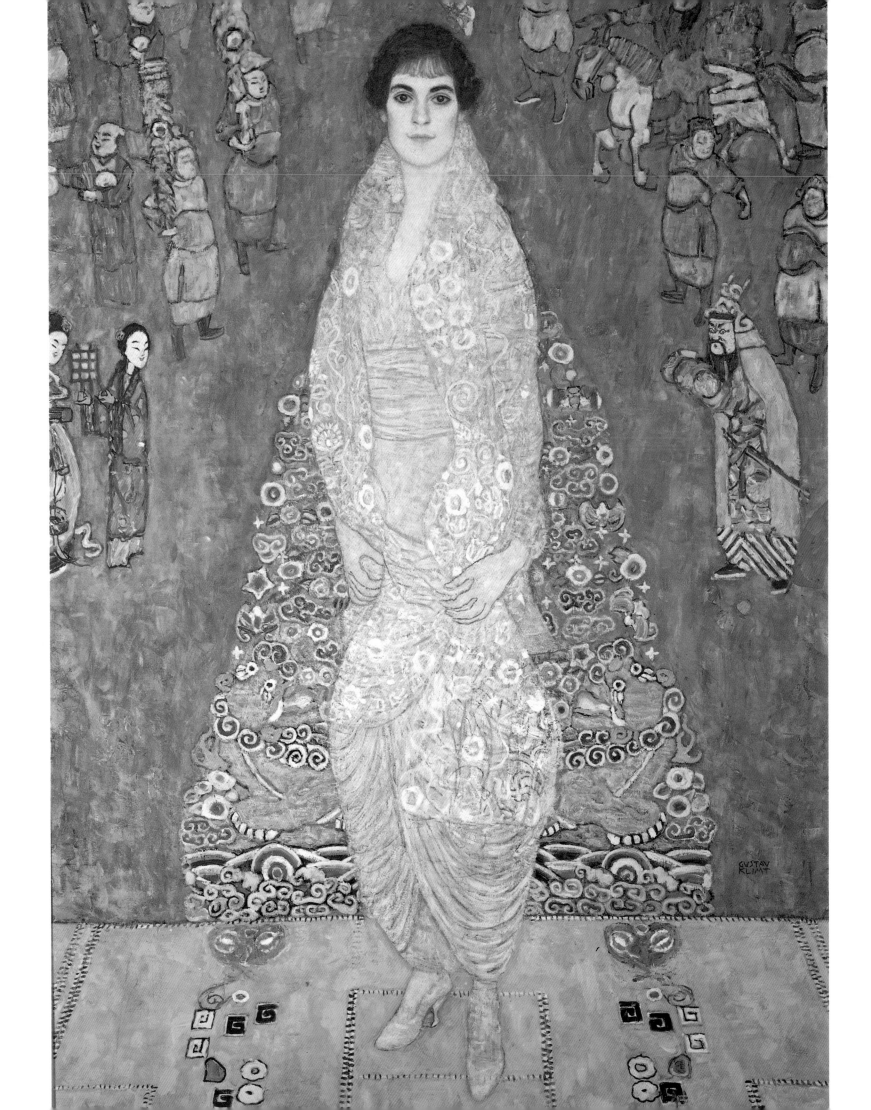

PLATE 48

Friederike Maria Beer, 1916
Oil on canvas, 168 × 130 cm
Inscribed b.l.: GUSTAV KLIMT 1916; t.r.: FRIEDERIKE MARIA BEER
Privately owned

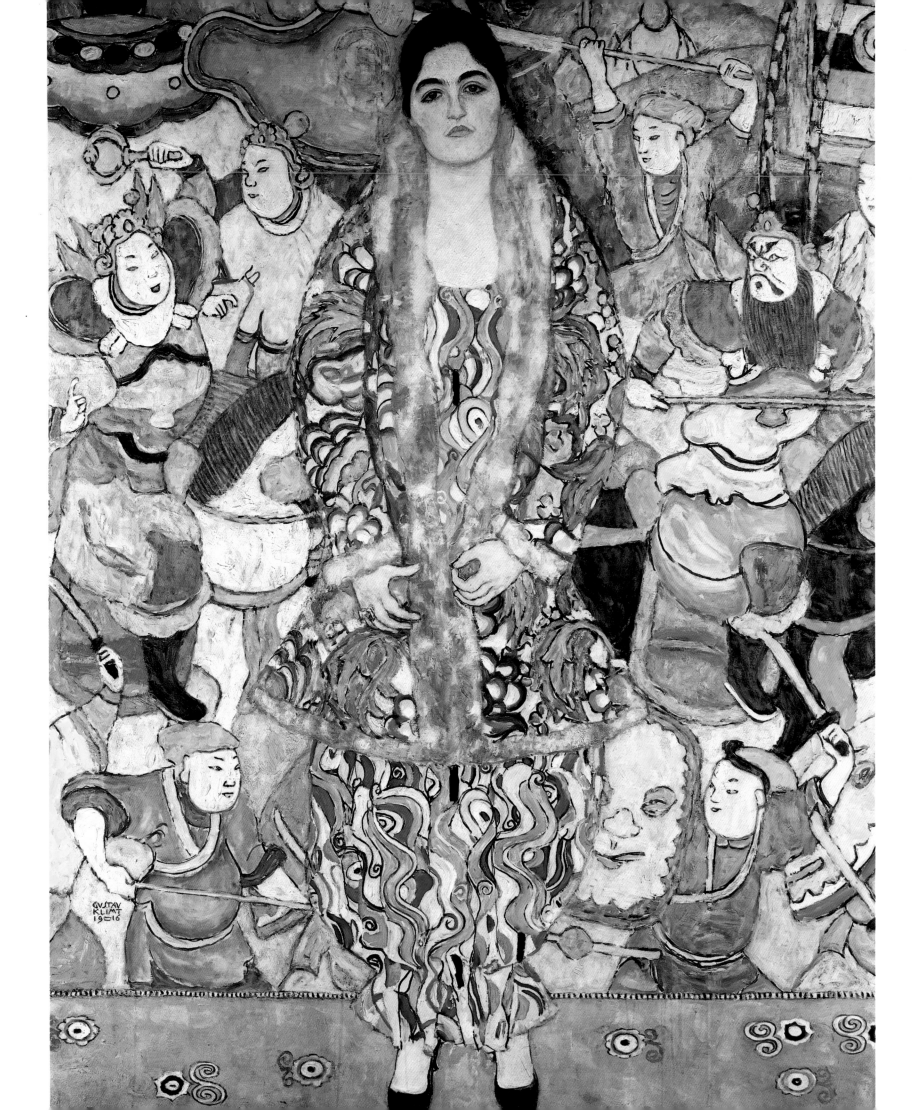

PLATE 49

Women Friends, 1916–17
Oil on canvas, 99 × 99 cm(?)
Inscribed b.l.: GUSTAV KLIMT
Destroyed by fire in 1945

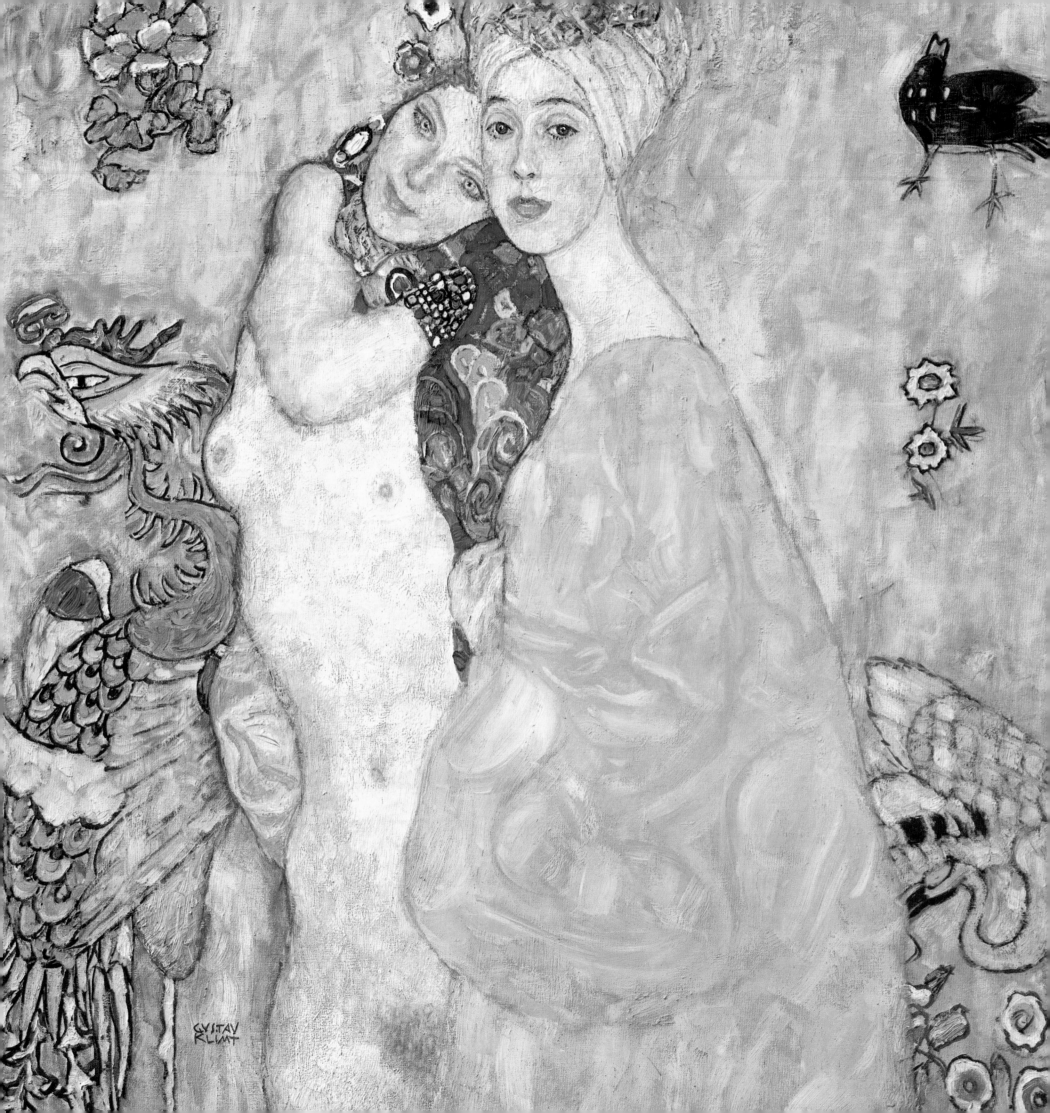

PLATE 50

Lady with Fan, 1917–18
Oil on canvas, 100 × 100 cm
Privately owned

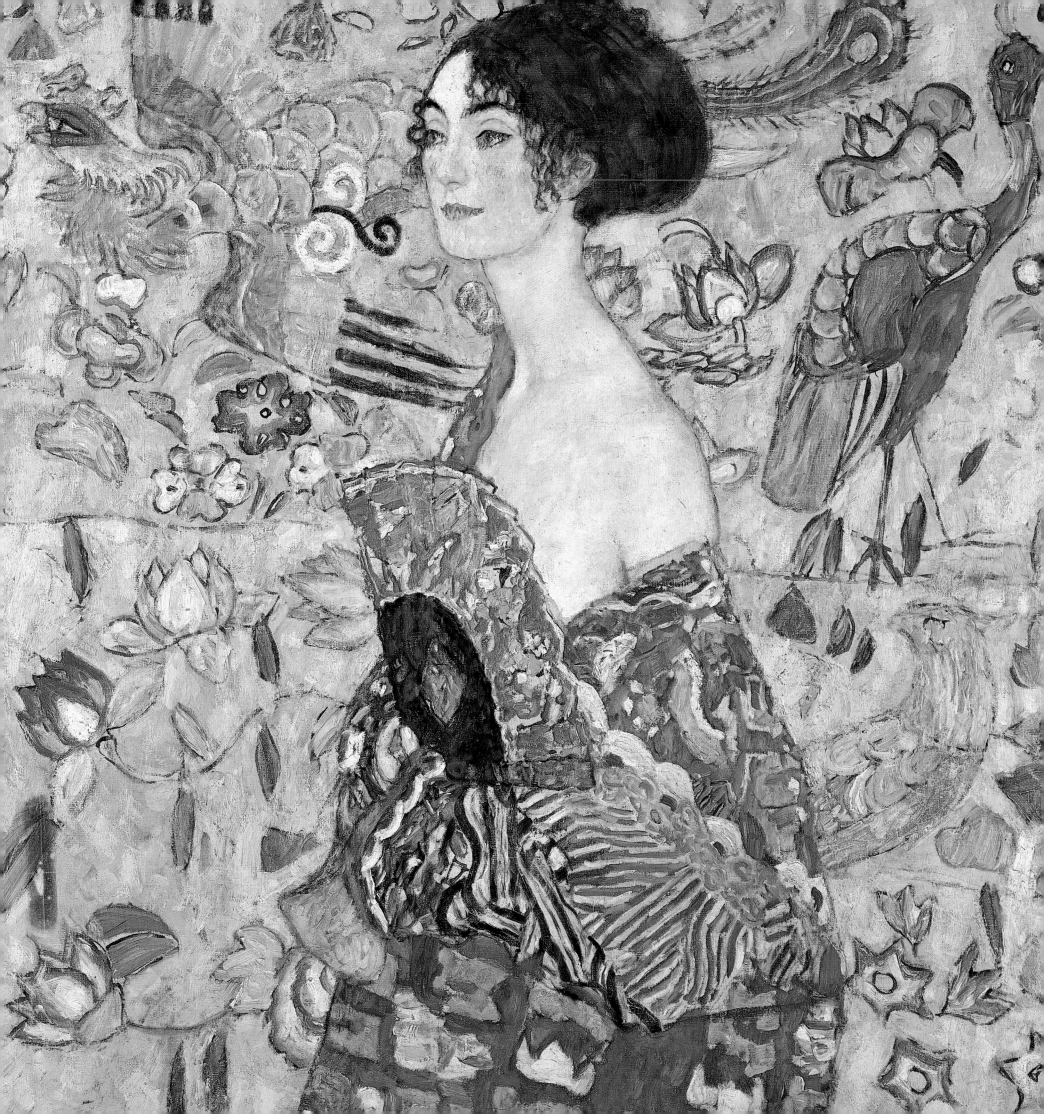

PLATE 51

The Dancer, *c.* 1916–18
Oil on canvas, 180 × 90 cm
Privately owned; photograph by courtesy of St Etienne Gallery, New York

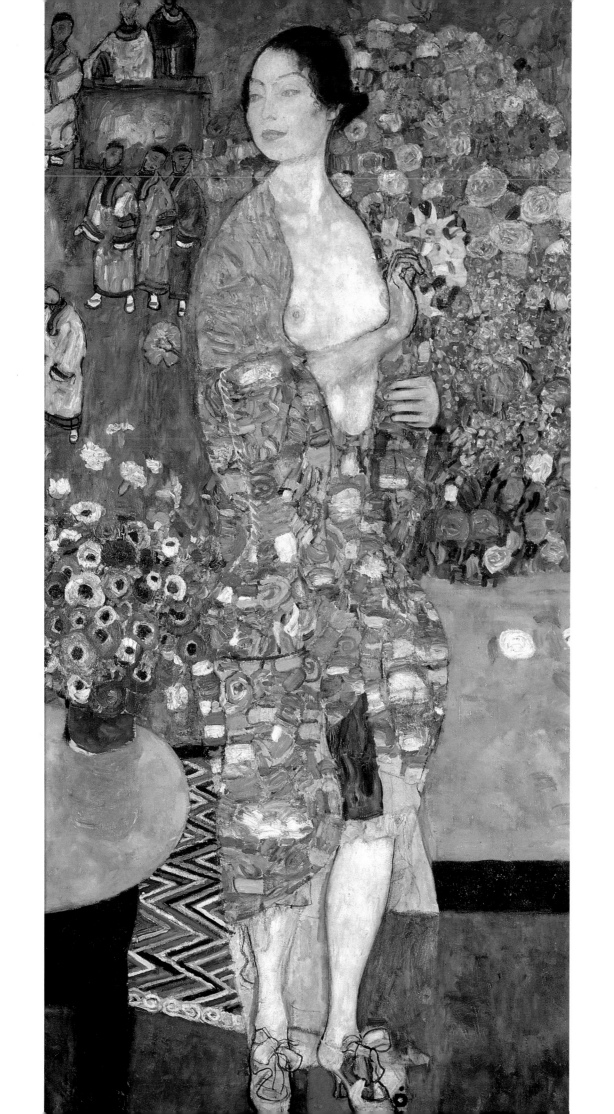

PLATE 52

Portrait of a Lady, 1917–18, unfinished
Oil on canvas, 180 × 90 cm
Neue Galerie der Stadt Linz, Wolfgang Gurlitt Museum

PLATE 53

Portrait of a Lady in White, 1917–18, unfinished
Oil on canvas, 70 × 70 cm
Österreichische Galerie, Vienna

PLATE 54

Johanna Staude, 1917–18, unfinished
Oil on canvas, 70 × 50 cm
Österreichische Galerie, Vienna

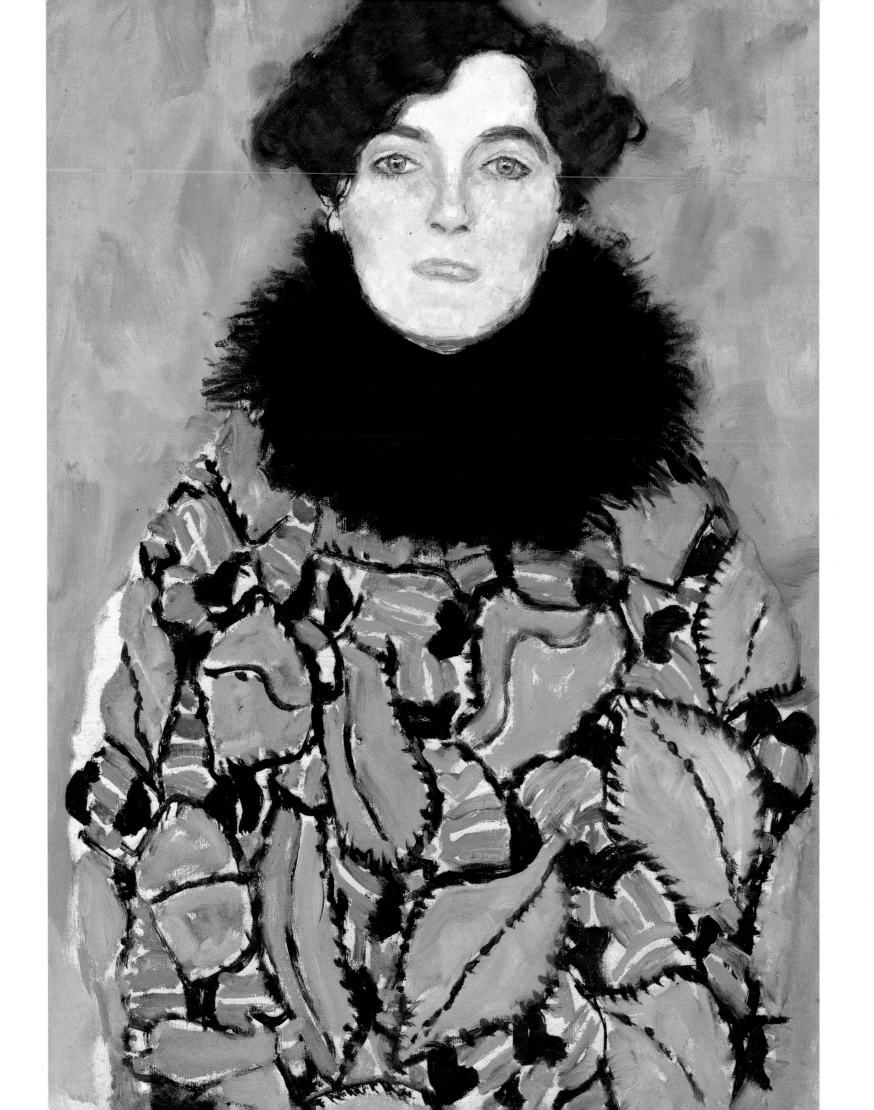

PLATE 55

Full-Face Portrait of a Lady, 1917–18, unfinished
Oil on canvas, 67 × 56 cm
Neue Galerie der Stadt Linz, Wolfgang Gurlitt Museum

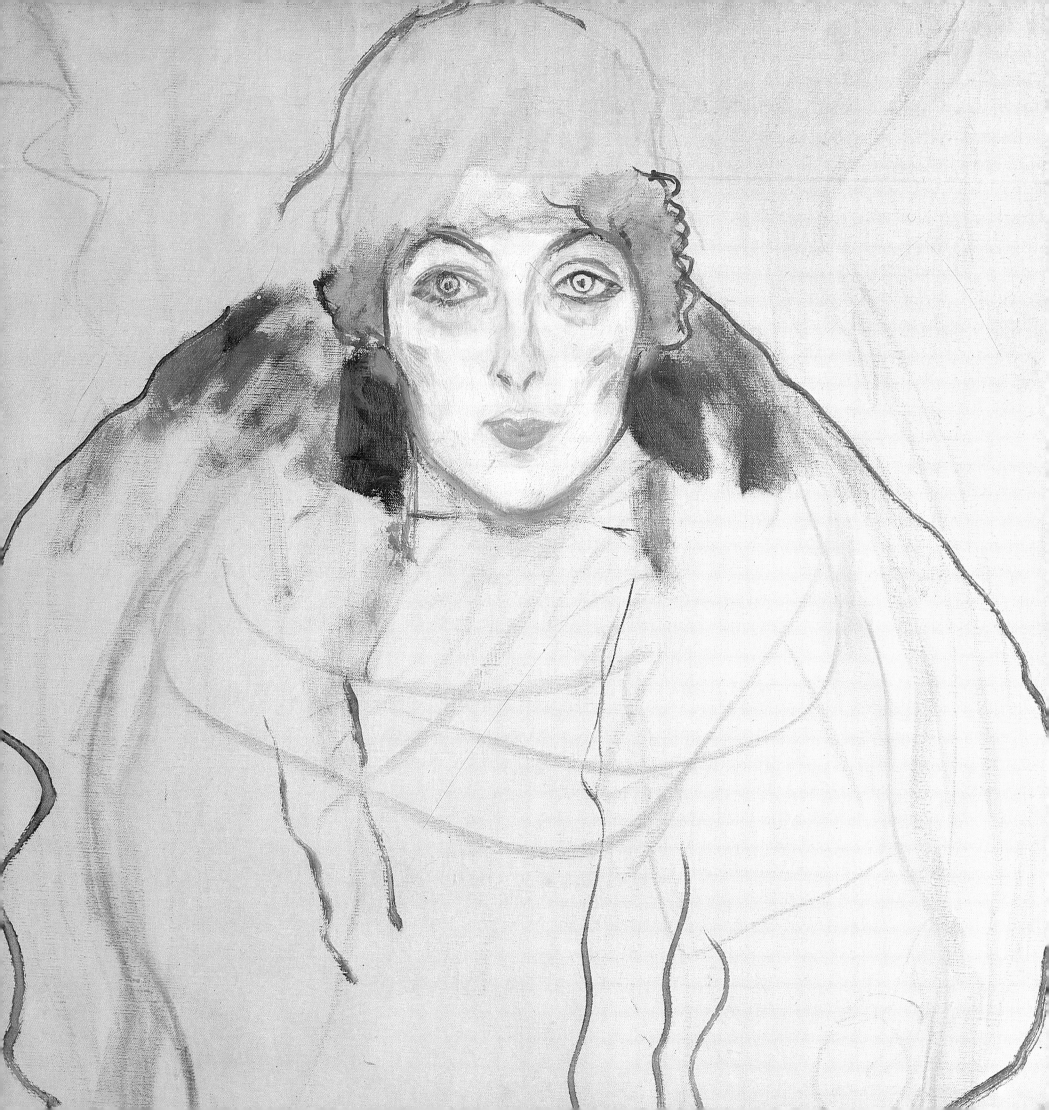

PLATE 56

Amalie Zuckerkandl, 1917–18, unfinished
Oil on canvas, 128 × 128 cm
Privately owned

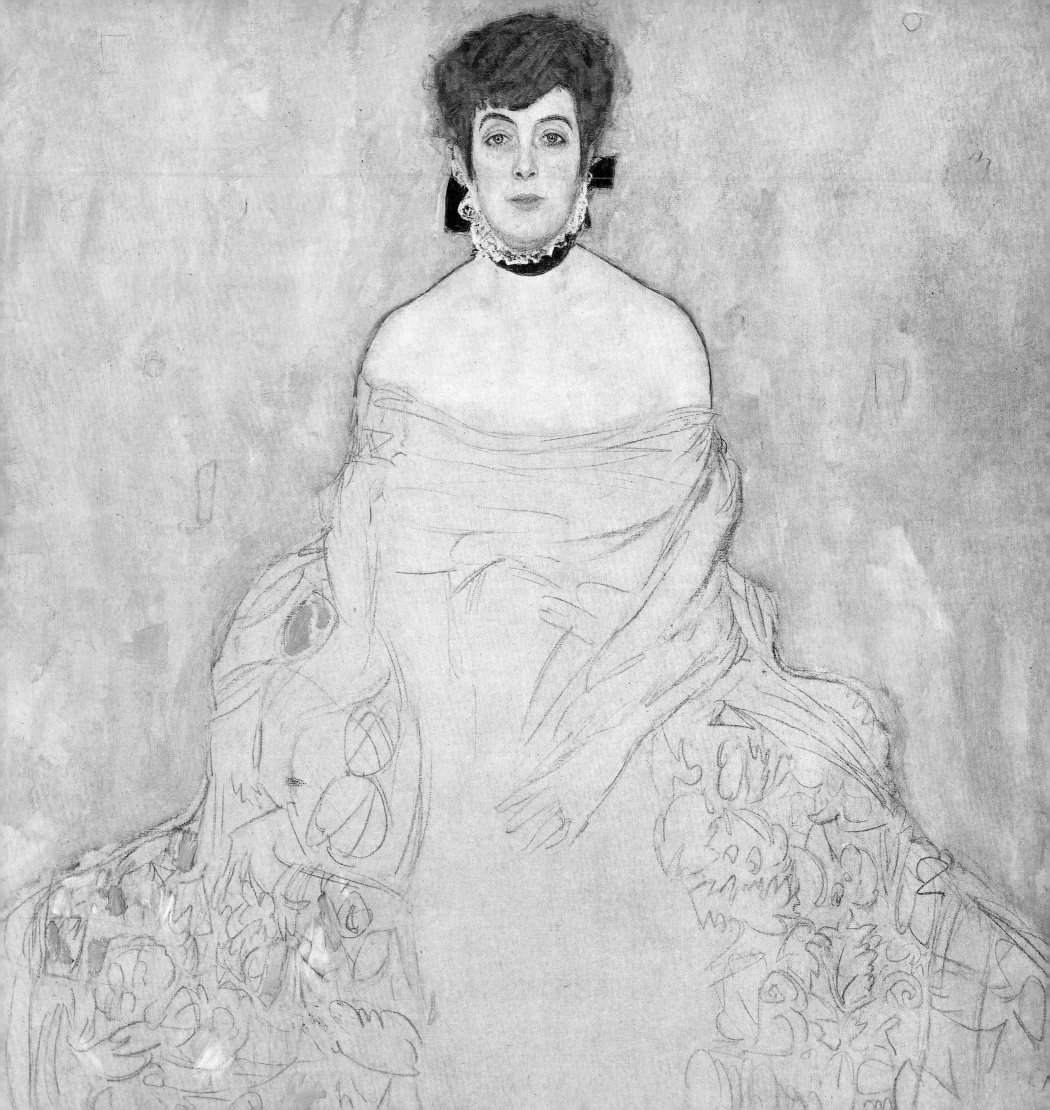

PLATE 57

The Bride, 1917–18, unfinished
Oil on canvas, 166 × 190 cm
Privately owned

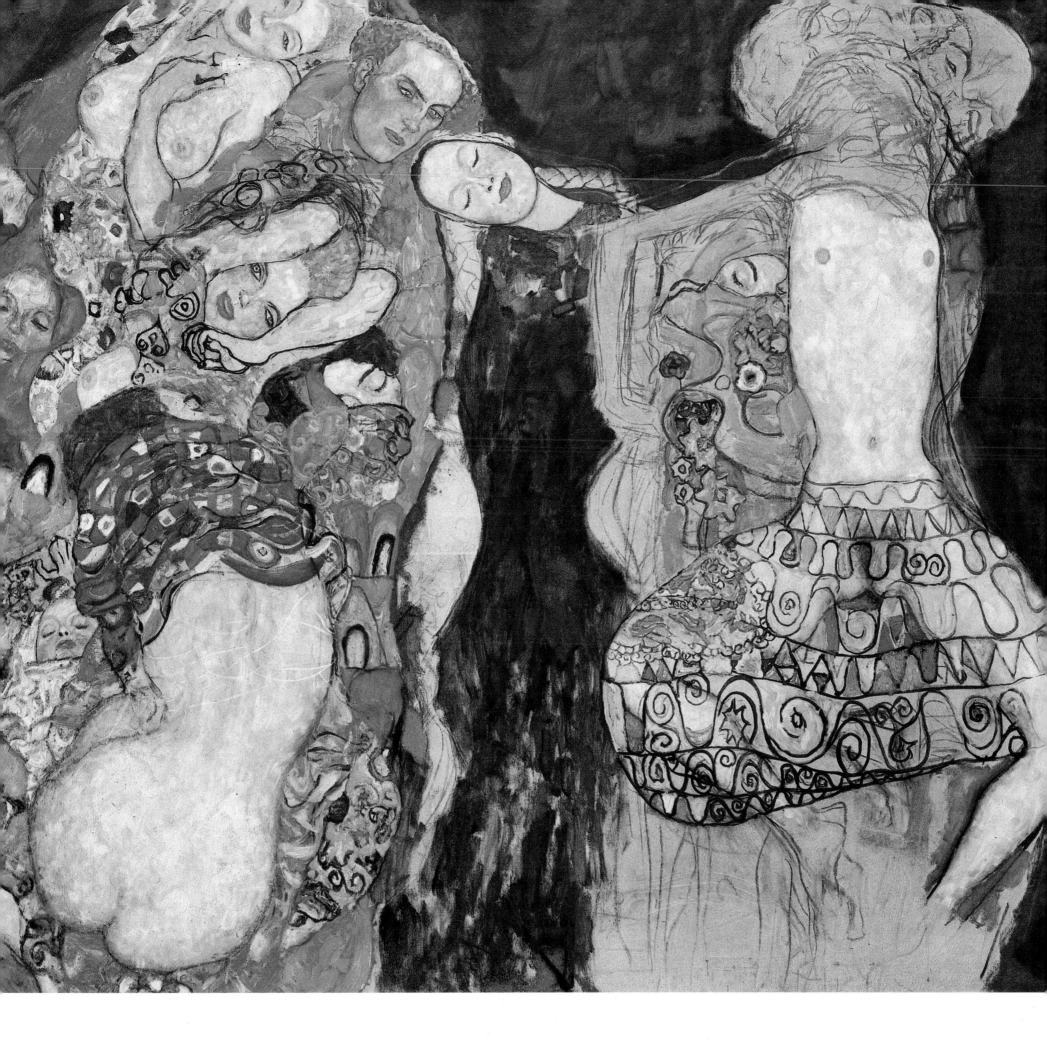